THE

Selfie!

BOOK

Published by Prion

An imprint of The Carlton Publishing Group

20 Mortimer Street

London W1T 3JW

Copyright © 2015 Carlton Books Limited

ISBN: 978-1-85375-883-6

10 9 8 7 6 5 4 3 2 1

Printed in China

THE Selfie! BOOK

Taking and Making the Best Selfies, Belfies, Photobombs and More...

Carrie Barclay and Malcolm Croft

PRION

Contents

Welcome to Selfie Heaven 6

How to Take the Perfect Selfie 8

Selfies with a Purpose! 10
Back to Front: Camera Skills 12
Lights! Camera! Selfie! 14
Watch Your Back! 16
Strike a Pose! 18

Types of Selfie 20

Belfies 22
Welfies 28
Pelfies 32
No-Make-up Selfies 34
Don't Try This At Home! 36
Drelfies 38

Super Selfie Styles! 40

Bedtime Selfies 42
The Duck Face 44
Hot Dog Legs 46
Bathroom Selfies 48
Just Like Us 52
I-Saw-A-Celebrity Selfie 56
The OMG-I'm-So-Jealous Selfie 58

Best. Selfies. Ever! 62

Epic Selfie Fails 80
Celebrity Photobombs 90

In January 2011 Instagram user Jenn Lee was the first person in the world to use "#selfie", along with this picture. There are now more than 150 million "#selfie" on Instagram.

Selfie Fever! — 100

Top Five Selfie Filters — 102
Selfie App-iness! — 104
The Rules of Selfie Photoshopping — 106
The Selfie Stick — 110
The Selfie Head Tilt — 112
Say #Hello to Hashtagging — 114
Selfie Etiquette — 116

Selfie-by-Numbers — 118

Selfies in the News — 126

Selfie Trends — 136

Throwback Thursdays (or *TBT*) — 138
Selfie Sundays — 142

Credits — 144

HELLO THERE.
WELCOME TO SELFIE HEAVEN.

It's official. Selfies are the best thing since bread came sliced. Or to be even more accurate, since your ultra-fancy smartphone came with a front-facing camera.

From their very humble beginnings as the first "profile pictures" posted on MySpace (remember that?), often taken when we were a bit drunk in our bathrooms or bedrooms, selfies have grown into the world's favourite social media trend. With the rapid explosion of high-quality camera phones, scores of easy-peasy photo editing apps available at the touch of a button and, obviously, the proliferation of social media sites such as Instagram, Facebook and Twitter, the online world has become a breeding ground for taking the perfect picture of your lovely face, and sharing it with your closest friends, fans and followers.

In the noughties, the word "selfie" practically became a brand-name product all of its own. With hundreds of millions of social media users sharing their photos on Twitter, Facebook and Instagram every day, countless celebrities all scrambled to show us their take on the perfect selfie. And with the unexpected rise of selfies, scientists and psycologists have now begun dissecting the social and cultural impact behind them. Basically, they all think we are a bunch of narcissistic weirdos and, who knows, they may be right!

Right now, selfies are an unavoidable part of every day life and social networking. You could be at home chilling on the sofa, in/on the toilet, or just bored at work – selfies are everywhere and have become a universal way of expressing our split-second emotions.

Carrie Barclay is a lifestyle writer, who was named as one of the top five female bloggers in the UK by the Huffington Post 2013. Carrie has also recently been shortlisted as one of Red magazine's Red Women of the Year 2014.

Malcolm Croft is a former music journalist and popular culture Commissioning Editor. He is the author of more than 20 popular culture titles that cover a wide array of subjects.

With more than one hundred million selfies uploaded and shared every day by 2014, it wasn't long before selfie-mania reached a new level of critical mass and celebrities started realizing the exciting potential. It's true – selfies lessen the impact of the privacy-invasion scandals caused by the increase in "paparazzi culture". A celebrity's motto soon became: a selfie a day keeps the paparazzi at bay. With selfies, celebrities are able to control precisely how they are perceived by the rest of the world. The same is true for us normal folk; we can communicate directly with the people who choose to follow us. And for this reason, perhaps more than any

other, selfies deserve to be celebrated more than ridiculed. After all, selfies are more than just the trendy buzzword of this generation, they are the modern window to our souls. And even if you think all that psychoanalysis stuff is nonsense, it doesn't matter – can you imagine a world without selfies now? I don't think so.

So, get that fancy smartphone you're always looking down at out of your pocket, flip it around and join in with the selfie revolution.

What's the worst that could happen?

Enjoy!

How To Take The Perfect Selfie

"I am actually turned off when I look at an account and don't see any selfies, because I want to know whom I'm dealing with. In our age of social networking, the selfie is the new way to look someone right in the eye and say, 'Hello, this is me.'
James Franco, undisputed King of the Selfie

Jennifer Love Hewitt shows us how to take the perfect selfie – almost. Perfect angle and lighting, but in this shot the phone's the main star, not the person. Always remember: look at the camera lens, not yourself!

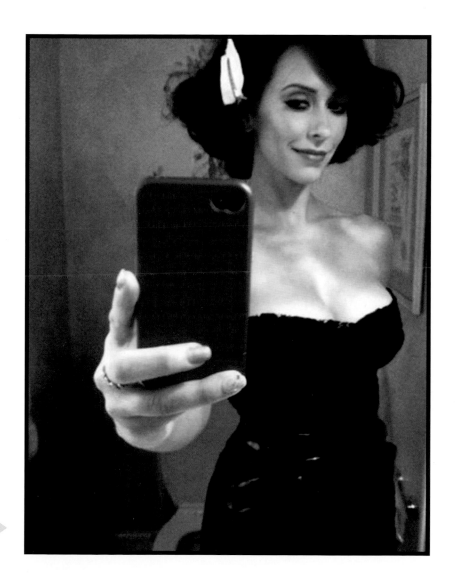

Selfies With A Purpose!

You'd think that the most important elements to taking the perfect selfie would be just "point, pout and shoot", right? No way. There's a load more to selfies than that. And we're here to show you how to do it just right. Once you've mastered these top tips and tricks, you'll be a selfie pro in no time…

#1 SHOULD YOUR SELFIES HAVE ANY MEANING?

This is just something to think about, not necessarily to take seriously! Are you showing off a new haircut, trying to make an ex jealous, or are you just in a silly mood (i.e. drunk)? Different purposes and intentions require different selfie setups. So before you pucker up and post, make sure you match up the selfie with the purpose perfectly. That way, you'll get the best reaction – whatever (and whoever) it is you're aiming for!

Brad Pitt's exes, Gwyneth Paltrow and Jennifer Aniston, share a happy selfie in aid of the 2014 Stand Up 2 Cancer event.

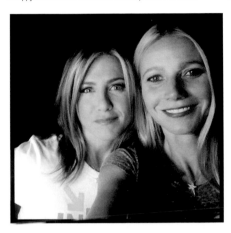

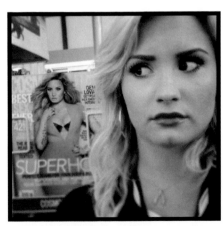

American singer Demi Lovato – and selfie-obsessive – takes an inspired selfie of herself that makes fun of her status as a celebrity figure.

TOP TIPS

1 Lighting should always come from in front of you

2 Take lots of pictures to select the best – you're unlikely to get it right on the first one

3 The best angle is 45º above your shoulder

4 Experiment with filters to see which are the most flattering

5 Stay up-to-date with current selfie trends

Back to Front: Camera Skills

#2 USE YOUR SMARTPHONE'S BACK CAMERA

Most smartphones these days have two in-built cameras: one in the back, and one at the front. When talking a selfie, always use the camera in the back. You can do this by pressing the icon that flips the camera around – you know the one. The back camera takes higher-resolution images than the front-facing camera. Downsides: You see a mirrored version of your own face as you take the selfie – and you'll have to turn the phone around and aim the angle, which can be difficult, especially when drunk and trying to cram in 12 friends – but it's worth it!

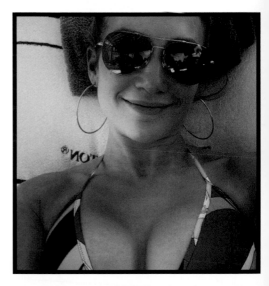

As you can tell from the reflection in J-Lo's sunglasses, the singer and actress knows how to take a spot-on selfie. By turning the camera around, she takes advantage of her smartphone's higher-resolution back camera.

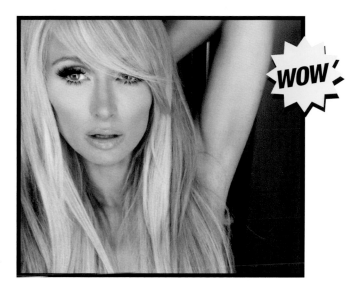

WOW!

Singer, socialite and selfie-ist Paris Hilton knows how to take the perfect selfie. A true selfie pro, Paris doesn't use a mirror — she turns her phone around.

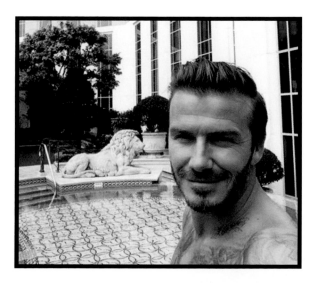

David Beckham's selfies are usually taken at exotic locations around the world, and often with his top off. He's a superb selfie taker, often getting excellent lighting and using his smartphone's back camera.

Lights! Camera! Selfie!

Lighting. Lighting. Lighting. The three most important elements to taking a selfie. Too many great selfies have been ruined by bad/fuzzy/blurry/bleached out lighting.

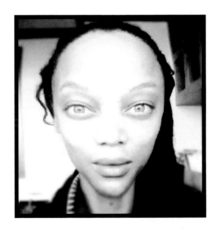

Supermodel Tyra Banks demonstrates how bad lighting accentuates unflattering features, as well as a pronounced forehead glare – avoid!

#3 LET THERE BE LIGHT

Everybody is in agreement that when it comes to taking the perfect selfie, natural lighting is the best way to achieve the most flattering shot. Stand by a window or head outside, if it's sunny. Avoid fluorescent lighting or dimly lit rooms. Don't rely on your camera's flash to provide optimum light – it tends to give your forehead an ugly glare and turns everything blurry, especially if you make sudden movements or have an unsteady arm. Keep the light source in front of you, above eye level. This will soften your features and stop shadows from creeping across your face.

Rihanna – an expert in selfie taking – uses natural light from a window to perfectly show off her best features (i.e. all of her).

American model Kate Upton posted this sizzling selfie in July 2014 and added the #nofilter hashtag along with cheeky caption "Because I'm in amazing light".

Watch Your Back!

With cheeky photobombers (and animals) desperate to ruin your perfect selfie, always check your surroundings before taking the shot – you never know who or what could appear just at the wrong time.

#4 MAKE THE MOST OF YOUR BACKGROUND

Selfie experts agree – the best selfies are those that contain more than just a face. The more background, or atmosphere, you enclose within the camera's frame, the more interesting the selfie becomes. Remember: selfies with amazing backgrounds tell a story – where you are, who you're with and what you're doing.

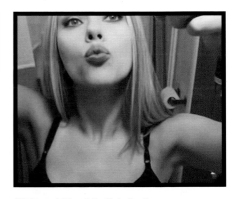

This immaculately well-lit selfie by the always beautiful Scarlett Johansson is slightly ruined by the toilet roll in the background.

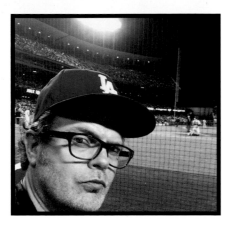

Funny man Rainn Wilson uses the floodlight to add some dramatic shine to his baseball selfie. His face is perfectly lit and the stadium behind him makes an exciting backdrop.

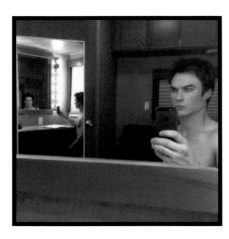

Ian Somerhalder's mirror selfie livens up a very boring dressing room background. Plus, you get to see the actor three times – always a bonus!

TOP TIPS

1 *Don't make the background too distracting, keep it clean and simple*

2 *Watch out for photobombers (see page 90)*

3 *Check your surroundings (make sure you don't have any incriminating evidence in the frame – an untidy bedroom, a poster of some guilty pleasure or a dirty pair of pants on the floor!)*

Strike a Pose!

While Madonna may not be the queen of the selfie (see page 81) she nailed it when she rapped in "Vogue", "… Don't just stand there, let's get to it, Strike a pose, there's nothing to it". She might as well have been singing about selfies!

#5 CHOOSE AN EXPRESSION THAT DEFINES YOU

Selfies are one of the greatest ways to express yourself exactly as you would like, and exactly as you would like the world to see you. When Benny Winfield Jr (aka Mrpimpgoodgame) posted over 600 selfies of himself pulling the same expression, he won over Instagram – and became an internet sensation. He now has over 230,000 followers, all desperate to see the same pose with each new post! If it worked for him, it can work for you. Work out your signature expression – something that defines you. But don't be afraid to mix it up a bit too!

Model Cara Delevingne often sticks out her tongue in her acclaimed selfies – in fact, she rarely pouts or behaves like models usually do!

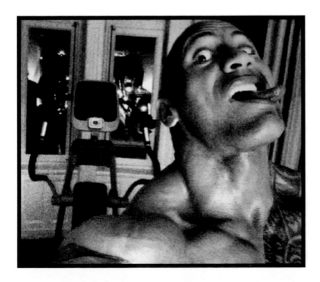

Dwayne Johnson always plays the funnyman in his hilarious selfies from his Instagram account. He certainly likes to pose topless – but then who can blame him with guns like that!

Types of Selfie

> 2014 belonged to the celfie – the celebrity selfie. Every famous person you could think, and even a few you would never have dreamed of, joined in. However, the selfie is constantly evolving into new, and hilarious, spin-offs that keep the selfie revolution alive and kicking!

Singing superstar Rita Ora takes a provocative poolside selfie. Her serious half-Duck-Face (a Duckling Face?) tells us that this selfie means business!

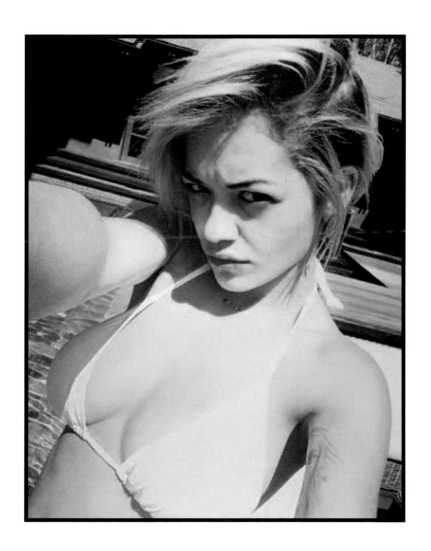

Belfies

Belfies, or bum selfies, were, perhaps, the most obvious choice for the next phase of the selfie evolution. One minute, selfies were all about the expressions on the face; the next, every celebrity in the world was getting ahead of the trend by posting a selfie of their behind…

#1 KIM KARDASHIAN – THE BEST BOTTOM SELFIE EVER?

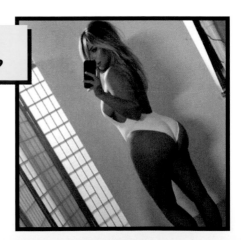

The most famous belfie (so far!) is, of course, Kim Kardashian's infamous butt-selfie. The US socialite and reality TV star, posted this photo of her curvy bottom and it made instant headlines on every social media site. This belfie has been often imitated and often parodied – but never bettered!

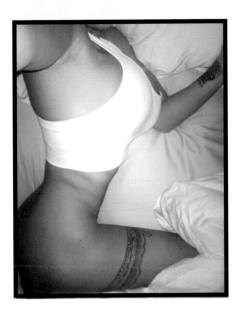

Katie Price, the glamour model formerly known as Jordan, shares a cheeky belfie on Twitter along with the caption "Being ill has defo made me lose weight".

BELFIE FACT:
2 out of 3 people have admitted to posting a belfie. Have you?

BELFIE RULES!

1 Use a mirror. Trying to take a belfie without one is hard to pull off, and you could strain something

2 Take lots of shots at different angles from various heights before settling on one you like

3 Don't try and disguise a belfie by pretending you're photographing your new jeans, shoes or belt – be proud of your bottom!

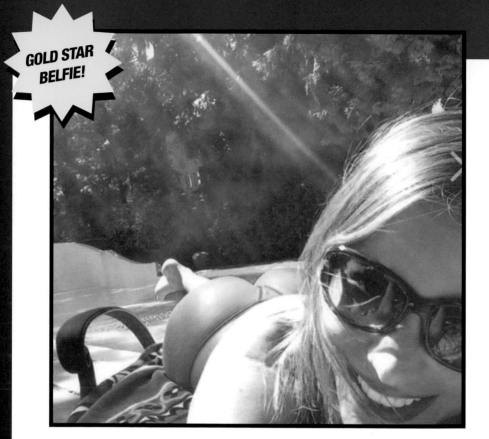

GOLD STAR BELFIE!

#2 SOFIA VERGARA

The fiery *Modern Family* TV star, and former model, spices up her Instagram account by posting this super belfie to tease her fans. The entire world re-posts it. Was it intended to be a regular selfie by the pool and her butt just got in the way? Who knows – but as belfies go, it's one of the best!

#3 AUBREY O'DAY

Singer-songwriter O'Day, and former member of Danity Kane, posted a split-screen frontie and belfie, much to the delight of her 350,000 Instagram followers. In her time on the social media site, the talented performer has posted many tantalizing selfies – but this one below takes first prize.

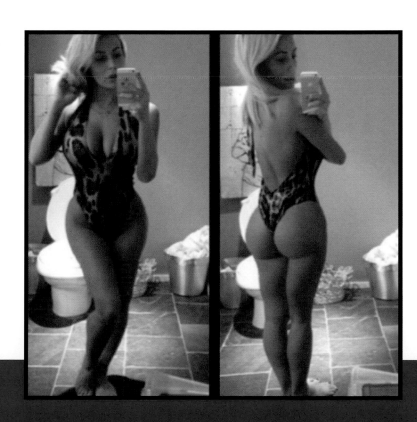

#4 CANDICE SWANEPOEL

The South African supermodel is one of Instagram's most followed models and, coincidentally, Number 10 in Forbes' richest supermodel list. As celebrity belfies go, this is one of the most elegant ones.

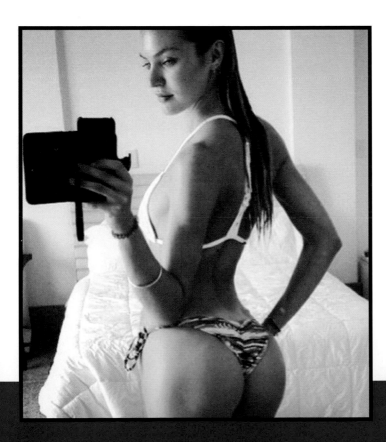

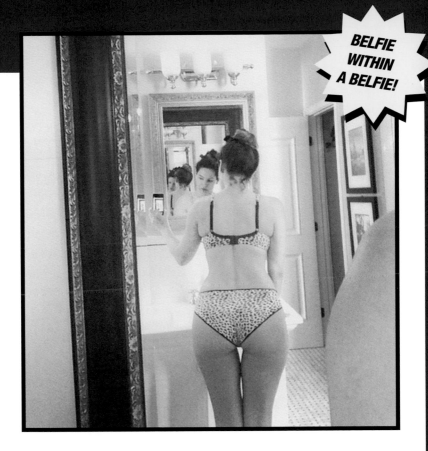

#5 KELLY BROOK

UK TV presenter, model and actress Kelly Brook is famed all over the world for her immaculate curves. This particular mirror belfie – in classy black and white no less – was shared by her millions of fans thousands of times.

Welfies

2

Hot on the heels of belfies comes one of the most popular selfie spin-offs amongst celebrities – the welfie. The "workout selfie" has boomed in the last 12 months with body-conscious celebs desperate to show off their reduced bingo-wings and increased abs, quads and glutes. Sure, us Regular Joes have been doing it too, but with nowhere near as much style.

#1 MEL B

The X Factor judge has been a gym-holic ever since the beginning of her Spice Girls career – and is now even more stacked than Sporty Spice!

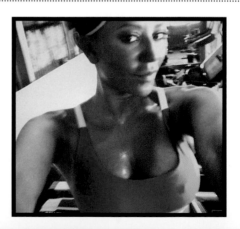

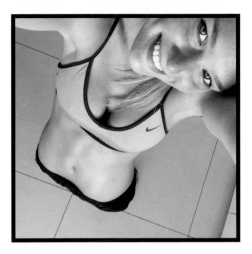

Supermodel Bar Rafaeli makes us want to puke at the sheer magnificence of this welfie. Do yours look like this?

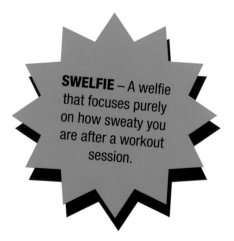

SWELFIE – A welfie that focuses purely on how sweaty you are after a workout session.

1 Focus on the area of your body that is still bulging after a workout

2 Use a mirror – it will help to capture a full length body shot

3 Don't get your camera wet with sweat!

4 Post only one welfie per workout session – so as not to appear too vain!

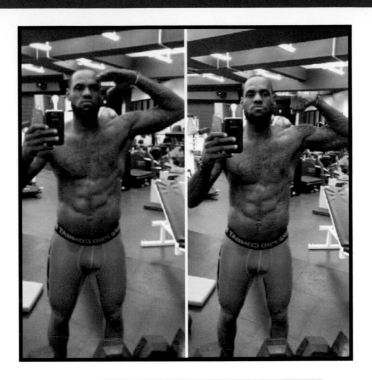

#2 LEBRON JAMES

One of the most influential and famous American atheletes of the modern age, LeBron James may well be a hit on the court for the Cleveland Cavaliers, but he is also a hit for his seven million Instagram followers too – and no wonder, considering his famous love of very impressive welfies.

#3 CHRIS PRATT

Star of *Guardians of the Galaxy* and *The Lego Movie*, soon-to-be-massive acting legend Chris Pratt has been entertaining his millions of followers with undeniable proof of how hard he has to train to become a Hollywood heartthrob.

WELFIE HEAVEN!

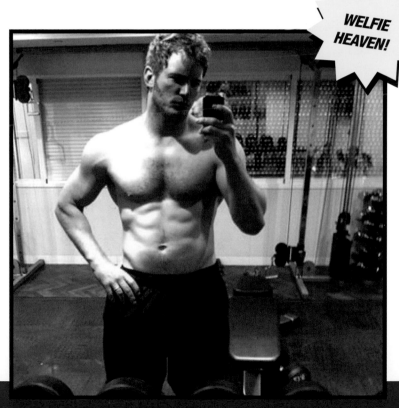

Pelfies

While "felfies", or farm animal selfies, have taken social media by storm, often showing farmers being bitten, butted or abused by their livestock, it is celebrity pet selfies, or pelfies, where the real stars come out to play.

Whether it's Paris Hilton's Tinkerbell, Miley Cyrus's Emu, Selena Gomez's Baylor or Snooki's Lorenzo, modern celebrities are in love with showing off their crazily named pets online. Many psychologists believe that celebrities become more "real" if they are seen loving and cuddling their pets.

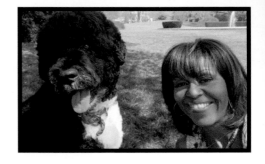

#1

The First Lady's famous Instagram pelfie with First Dog, Bo, was part of *National Geographic*'s Great Nature Project, which aimed to create the world's largest online album of animal photographs.

#2

The raunchy US singer Katy Perry takes a lot of selfies with her pets. Jiff, pictured here, features heavily.

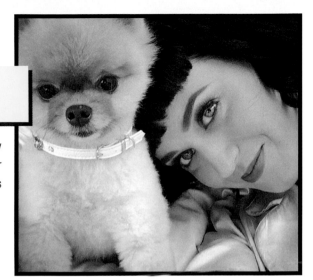

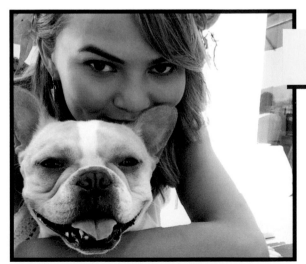

#3

Chrissy Teigen, *Sports Illustrated* model and wife of the music superstar John Legend, never goes anywhere without a) her husband b) her three-legged dog Penny, and c) taking selfies!

No-Make-Up Selfies

4

The selfie hit a new high in March 2014, when news of the #nomakeupselfie campaign started to trend globally and reach out into all areas of social media, as well as the greater public at large. Within just a few days, everybody had joined in and, at its zenith, the first-of-a-kind Anti-Cancer campaign had raised two million pounds and kickstarted scores more charity campaigns, including the #ALS Ice Bucket Challenge.

While many hundreds of thousands ordinary people posted selfies containing no make-up, it was the celebrities who made the difference by mucking in too – by not putting any muck on. For the first time we saw our favourite celebrities without any magical make-up on – and it encouraged large swathes of image-conscious people to do the same. While many people considered the campaign a rebellion against artificial body images in the media, many also thought the campaign was a revolution. Here are our favourites...

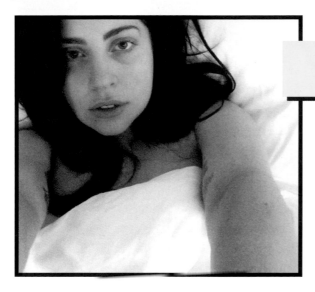

#1 LADY GAGA

Normally covered in make-up or some arty get-up, Lady Gaga is rarely seen as her plain-clothed alter ego Stefani Joanne Angelina Germanotta, so this no make-up selfie was indeed a real treat for her millions of "little monsters".

#2 JENNIFER LAWRENCE

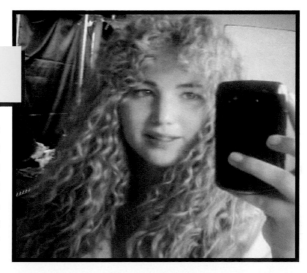

Whether it's tripping up on the red carpet on burping during live TV interviews, Jennifer Lawrence is the queen of not really caring about her lady-like appearance. This no-make up selfie shows the Oscar-winning actress at her most beautiful. Love that hair!

Don't Try This At Home!

5

Daredevils, show-offs, thrillseekers, whatever you want to call them, one thing is clear: the world is becoming increasingly proud of its extreme selfie takers – the people who take their faces and their cameras to the limits. No sooner had selfies become an everyday part of life than hundreds of extraordinary and unbelievable extreme selfies started showing up on everybody's Facebook newsfeed...

#1 KIRILL ORESHKIN

Dubbed "Russia's Spiderman" by the world's media, teenager Kirill Oreshkin has climbed many of Moscow's tallest landmarks, unaided, before taking a selfie that has gone on to stun the world.

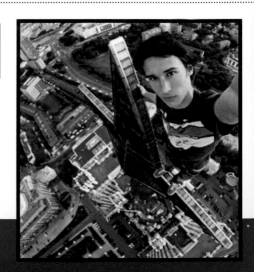

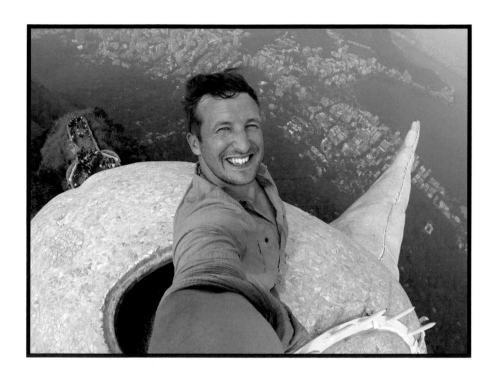

#2 LEE THOMPSON

Often named the "best selfie ever", this was taken by Lee Thompson, who climbed 124ft (38m) to the top of the Christ Redeemer landmark in Rio, Brazil armed with only his camera and a spectacular selfie smile!

Drelfies

6

DRUNK AND HUNGOVER SELFIES

Drunk selfies, or drelfies as they are increasingly becoming known, are, as you would expect, the most common selfie type available online. While most intelligent people (including celebrities) aren't silly enough to post the worst of their drelfies online, many people are hungover enough to post hung-over selfies – vulnerable moments taken in the morning of the night before...

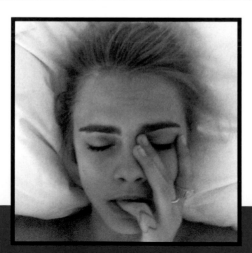

#1 CARA DELEVINGNE

Cara Delevingne is winning the selfie war. Her Instagram account is action-packed with hilarious shots of many wonderful things, though this selfie after a particularly "epic" night out with Rihanna is priceless. It was shared more than 3 million times!

#2 SELENA GOMEZ AND ZOOEY DESCHANEL

TV star and girl-next-door beauty Zooey Deschanel, and BFF Selena Gomez, posted an almighty boozy selfie that caught the headlines of the online media. Though they both still look beautiful, it's definitely time for bed.

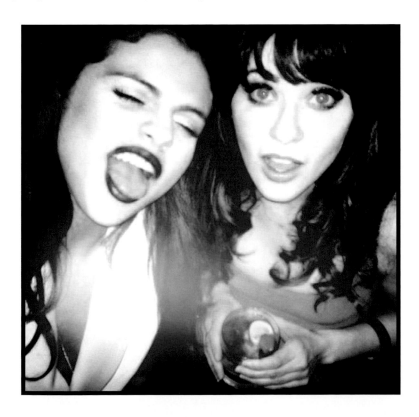

Super Selfie Styles!

> Instagram, Twitter and Facebook may be the three most popular social networking sites to share your selfies, but when it comes to the possible combinations of selfie spin-offs you can actually take and share, the number is close to infinity. Here are some of the very best types of selfie styles that are currently rocking the online world. How many of these have you taken?

President Barack Obama and Vice President Joe Biden share a selfie, or "ussie", in the back of the Presidential State car, known affectionately as The Beast.

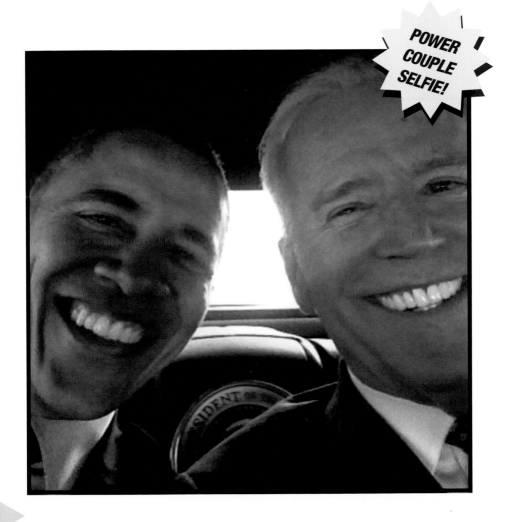

POWER COUPLE SELFIE!

Bedtime Selfies

For some, bed selfies are great ways of boasting to the world how early you have to get up. For others, it's a way of boasting how late you've gone to bed and who with. For celebrities, however, it's an easy excuse to tease your fans with how amazing you look curled up and snuggled in bed.

#1 CHERYL ~~TWEEDY COLE~~ FERNANDEZ-VERSINI

The chart-topping singer's Instagram fans get a goodnight kiss in bed when she is in a playful mood. Lucky them!

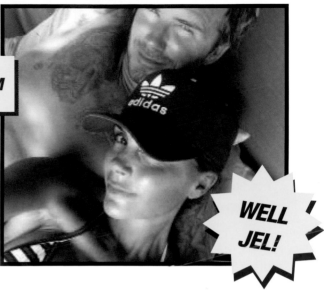

#2 VICTORIA BECKHAM

Just when you thought life was already unfair, Victoria Beckham goes and posts a bed selfie with her topless heartthrob husband, David.

WELL JEL!

#3 SHANE WARNE

Australian cricketing hero and beau of Elizabeth Hurley, Shane Warne caused a stir with a string of sexy bed selfies that no doubt got his Instagram fans hot under the duvet. "Dad, take this down," Warne's 11-year-old daughter Summer posted. Eventually, he did.

The Duck Face

Possibly the most fashionable of all selfie poses, ladies and gentleman, this style needs no introduction. It is, of course, the Duck Face. Famous previous owners include, well, everyone, from Mary Kate and Ashley Olsen to Shakira and perhaps most famously of all, Derek Zoolander.

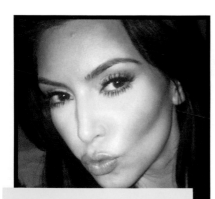

#1 KIM KARDASHIAN

The Queen of Duck Face.

THE MOST POPULAR SELFIE FACE ... EVER!

On average, 2 out of 5 selfies contain The Duck Face, the pout that puckers the lips and draws the cheeks in. It makes you look thin, basically! As Selfie Queen Kim Kardashian once famously said about how to take the perfect selfie, "You always need your phone to be a little bit higher than lower ... and know your angle. And know duck face! I love that expression because it gives you cheekbones!"

#2 ROSIE HUNTINGTON-WHITELY

This supermodel's selfie pout means business!

BREAKING NEWS: The Duck Face has evolved – the latest trend is now the Sparrow Face. Check it out!

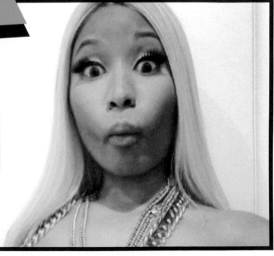

#3 NICKI MINAJ

This controversial singer is renowned for baring all in her selfies, but she's also known for her wicked Duck Face too.

Hot Dog Legs

While critics denounce this selfie style as being the most annoying vacation snap ever – or worse, just a blatant attempt to show off your suntanned legs – the real truth is people who complain about Hot Dog Legs are only jealous of your delicious-looking limbs.

FANTASTIC FRANKFURTERS

While your legs may indeed look just like two overcooked sausages lying on the beach, Hot Dog Leg selfies have now become one of the most commonly posted selfie types when on vacation. So much so, that there is now a wave of daft spoof selfies doing the rounds – people taking actual frankfurters to the beach, posting a picture and then challenging people as to whether their "legs" are genuine legs or a pair of hot dogs. It's actually quite hard to tell the difference. Look it up, if you don't believe us!

#1 HEIDI KLUM

The German supermodel caused a tsunami of "Likes" when she posted this now-infamous selfie of her legs.

#2 IRELAND BALDWIN

Unlike real hot dogs, actress Ireland Baldwin's hot dogs look good enough to eat. Ireland's Instagram acount is full of exotic sun-kissed destinations, but this one is the best by far.

Bathroom Selfies

Whether it's because of the bright fluorescent lighting or the convenient plethora of mirrors, the bathroom, rather oddly, is one of the most popular selfie locations, if the least sanitary.

> I think this world would be better off having more women holding a fish in a picture than holding their camera in front of a bathroom mirror, taking a selfie.
>
> *Sarah Palin, on behalf of fish everywhere*

#1 KIMYE

Kanye West, the American rap superstar, and wife Kim Kardashian pose for a bizarre shared bathroom selfie experience. Let's hope they both washed their hands after.

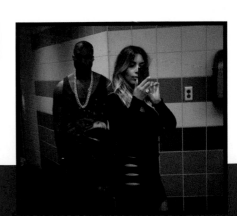

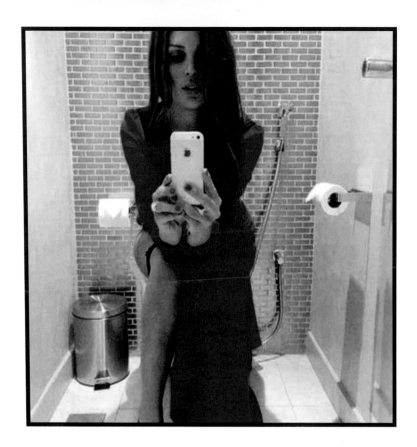

#2 DANIELLE LLOYD

UK TV presenter and model Danielle Lloyd posted this telfie – or toilet selfie as it's increasingly becoming known – along with the caption "Posh wee wee in my gold toilet lol".This selfie made our day!

#3 JAMES FRANCO

James Franco's place as the Selfie King of the Internet is not in doubt. Though some questioned his decision to post this bathroom selfie – which was removed moments after Mr Franco posted it – the truth is the actor is always ahead of the curve when it comes to breaking down the barriers between celebrity and their selfies.

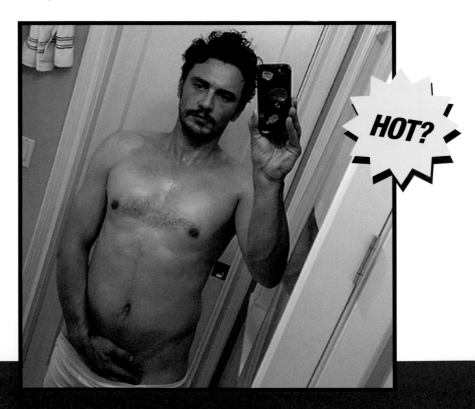

HOT?

#4 AMANDA BYNES

Amanda Bynes is a breakout TV and film star in the US. This bathroom selfie captures the star in a state of undress. While the actress has recently retired from acting after a particularly difficult year in the media spotlight, she occasionaly takes time to reveal all on her Twitter account.

Just Like Us

When it comes to selfies, celebrities are just like everybody else. They love a good selfie with their friends. But when their friend is also famous, it can get a few fans a bit hot under the collar. Everybody loves a two-for-one deal – but these selfies are just ridiculous...

CELEBRITIES WITH CELEBRITIES

Let's face it. Without celebrities, selfies wouldn't be half as interesting. There is something about looking at celebrity selfies that goes straight to the core of the human experience. Dr Aaron Balick, a psychotherapist who has written a book about the human motivations behind social networking, says: "A selfie is an expression of an active online identity, something you have control over. You might take lots, but you'll publish the ones you like – even if they are silly or unflattering. Celebrities like selfies – because they can control them."

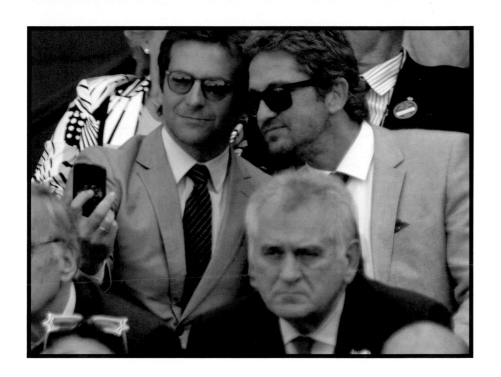

#1 BRADLEY COOPER AND GERARD BUTLER

Bradley Cooper is the king of celebrity selfies. Not only is he the proud owner of the most shared selfie in history (with Ellen DeGeneres and Co, at the Oscars – you know the one!), he also whipped the crowd at the Wimbledon semi-final 2013 into a veritable frenzy when he and his bromantic mate Gerard Butler posed for an innocent selfie. When the resulting image went viral – a wet dream of mega-celebrity selfie proportions – Bradley Cooper claimed he had no idea how much of a fuss he had caused with his female admirers.

#2 LILY ALLEN AND LEONARDO DICAPRIO

Lily Allen is England's Queen of the Selfie — a celebrity who gets as starstruck around other celebrities as her fans get around her. Lily's social media profiles are littered with Lily's amazing selfies with other celebrities. Her most famous surely was the snap above — with Leo DiCaprio onboard a luxury yacht!

#3 JENNIFER LOPEZ AND MICHELLE OBAMA

It was the dream meeting fans of abbreviations were waiting for
– singer J-Lo meeting FLOTUS Michelle Obama.

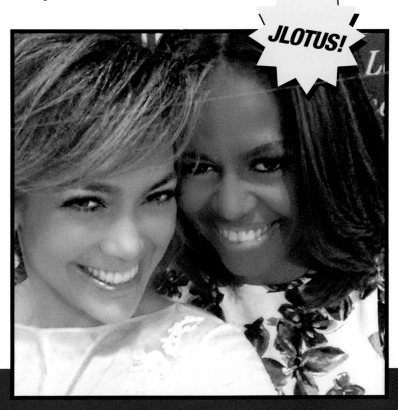

JLOTUS!

I-Saw-A-Celebrity Selfie

Long gone are the days of the celebrity autograph. These days people collect celebrity selfies. No matter whether its Russell Brand or Craig from Big Brother, everybody has, at one point or another, run down a street desperate to have a picture taken with a celebrity. Own up – who's yours?

I SAW A CELEBRITY SELFIE

The world is full of weird and wonderful people. Take Victoria Sky Ellis, for example. In just a few years, this celfie-fanatic has amassed over 10,000 selfies of her with her favourite A-list film stars and pop icons, from Tom Cruise to Brad Pitt, Lady Gaga to Vanilla Ice. "I'm completely obsessed", she claims.

#1 HER MAJESTY THE QUEEN

Getting the Queen to squeeze into your selfie is quite difficult, but Australian hockey players Jayde Taylor and Brooke Paris did it with aplomb at the Commonwealth Games in July 2014.

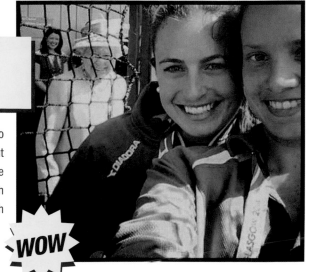

WOW

#2 SIR PAUL MCCARTNEY

Plucky teenager from Nebraska, Tom White confidently snapped two of the most famous (and richest) men in the world when he just happened to walk by and see Warren Buffet and Paul McCartney sitting down. McCartney retweeted the image – along with more than 2,000 other Twitter fans.

The OMG-I'm-So-Jealous Selfie!

Selfies can incite many complicated emotions – confusion, indifference, fear and WTF! Perfect celebrity selfies taken on exotic far-flung islands or looking naturally stunning while just laying in bed with a kebab, tend to stir up the worst human emotion of all, though: ENVY.

THE ENVY-INDUCING SELFIES

Selfie scientists have concluded that first impressions of beach selfies and holiday selfies of yourself looking sun-tanned and relaxed in exotic locations tend to stir up feelings of jealousy and bitterness first – rather than happiness from your friends, especially when they are stuck at their desks. They may press "Like" – but what they really want is a button that says "HATE!"

#1 HEIDI KLUM

Often regarded as the world's most beautiful woman – still – supermodel Heidi Klum's selfies send her social media followers into a dizzy rage everytime she tweets, posts and shares selfies of her incredible body. Stop it!

#2 MIRANDA KERR

The famous supermodel Miranda Kerr posts the most incredible selfies. It's no wonder she was the subject of a spat between former husband Orlando Bloom and popstar Justin Bieber in August 2014 – just look at her!

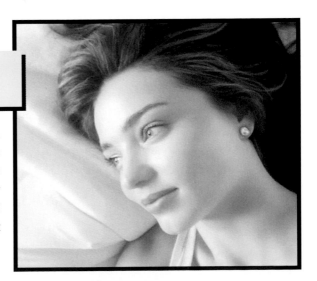

#3 SELENA GOMEZ

More than one million fans "Liked" this envy-inducing car selfie from April 2014. Selena Gomez is currently one of the most beautiful and talented young singers and actresses in the US, and the former girlfirend of Justin Bieber. This selfie was posted with the caption "iheart filterz". Can you guess which filter Selena used?

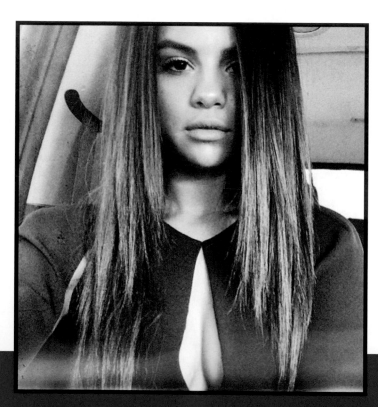

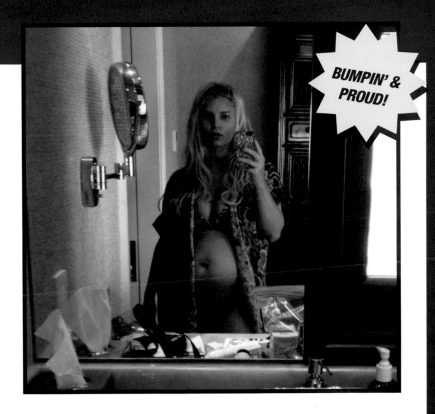

BUMPIN' & PROUD!

#4 JESSICA SIMPSON

The former reality TV star, singer and blondest blonde in the USA, Jessica Simpson is now wife and mom to two children. This "bumpin' and proud" bathroom mirror selfie from December 2012 made online headlines and showed the world that even when heavily pregnant, she could still be the best-looking blonde bombshell in the business.

BEST. SELFIES. EVER!

> They fill up our newsfeeds almost every day. We share them with our friends and family. We post them to our blogs and we talk about them at work. It could be a belfie or a drelfie, a close-up or a group shot. There are so many famous selfies its hard to know where to start. We love them all.

The world's most popular selfie: Ellen DeGeneres' Oscar selfie has now been retweeted more than two million times. Ellen's caption that accompanied the image was perfect too: "If only Bradley's arm was longer. Best photo ever." We couldn't agree more.

ELLEN DEGENERES AND CO. OSCAR 2014 SELFIE

Ellen's famous selfie from the Oscar Ceremony is the most tweeted image of all time with just under one million retweets within the first hour of being posted, beating Barack Obama's election night victory tweet in 2012. It's also the only time that Brad Pitt, Meryl Streep, Bradley Cooper, Julia Roberts, Kevin Spacey, Jared Leto and Jennifer Lawrence have shared the small screen all at once!

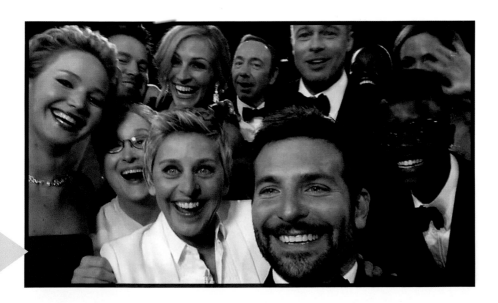

Social networking sites such as Instagram and Twitter, as well as popular culture "news" sites such as Perez Hilton and Buzzfeed, have exploded with stories that spoof the world's most discussed selfies. From politics to popstars and pets, no selfie is safe from a spoof...

DAVID CAMERON

When David Cameron posted a picture of him on the phone to President Obama the whole world patched themselves into the call too – with hilarious results. This was one of the earliest known selfie spoofs.

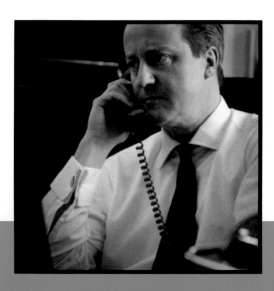

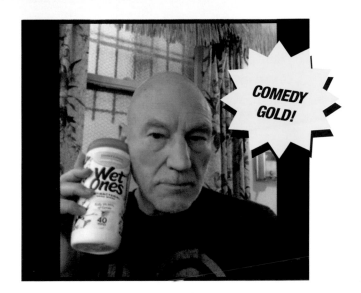

COMEDY GOLD!

Star Trek *and* X-Men *actor Patrick Stewart has become notorious for his selfies. But his famed spoofing — by holding a tube of Wet Ones to his ear — of Prime Minister David Cameron's phone call selfie to US President Barack Obama went viral and was shared hundreds of thousands of times and hit the headlines.*

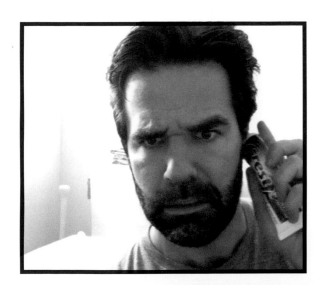

Often voted "one of the funniest comedians on Twitter", Rob Delaney got in on the action and spoofed the prime minister's call — "Hi guys, I'm on the line now too. Get me up to speed", he wrote. It was retweeted tens of thousands of times.

While pop stars and politicians have taken to social media sites to expand their brand and promote their new policies and pop records, many of the world's funniest comedians have also taken to selfies like the proverbial duck to water.

RICKY GERVAIS

Ricky Gervais' countless "ugly" bath selfies have entertained his "twonks" for a few years now. The most famous of all these selfies was when legendary US talk-show host Conan O'Brien joined him in the bath!

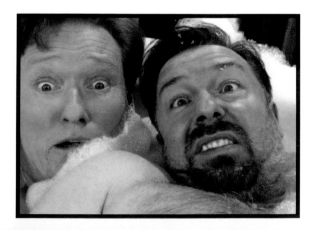

Ricky's infamous bath selfies have been shared and re-posted on sites all over the world – highlighting Gervais' personal brand of society-mocking comedy.

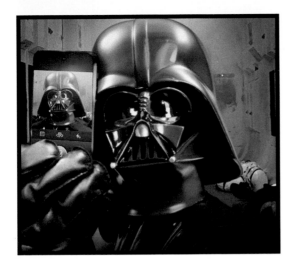

Darth Vader, via the Star Wars *Instagram account, ditched the Dark Side for a few seconds and posted this funny selfie from the* Death Star. *Hundreds of other similar selfie parodies began to pop up too.*

THE RISE OF THE PARODY SELFIE

As with all trends, fads and social movements, the moment it is adopted by the mainstream it also becomes a subject of parody and lampooned for its perceived silliness and trendiness. With selfies, there have been many spoofs that already have come and gone. The Sellotape Selfie was a popular trend in 2013 (Google it!) but quickly ran out of steam. The #antiselfie campaign that took root was also a predictable response to those who have come to hate selfies – but probably still take them!

Two of the most shocking, and obsessive, selfiers are also, coincidentally, two of America's most controversial pop singers. Along with Kendall Jenner, Lady Gaga and James Franco, Miley Cyrus and Nicki Minaj have become prolific selfie takers. Who takes the best? That's up to you to decide...

MILEY CYRUS

Billy Ray Cyrus's daughter, Miley, is currently one of the world's most prolific celebrity selfie takers with more than 150 selfies, in various moods, pets, locations and clothing – or lack thereof! Miley also has more than 12 million Instagram fans.

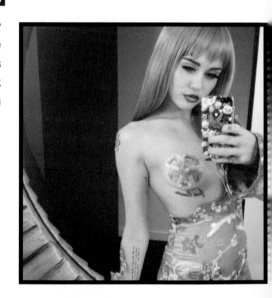

Miley Cyrus has a tendency to bare all in her selfies. She is one of the most expressionistic celebrities of the modern age. This famous selfie sees Miley in full Lil' Kim mode!

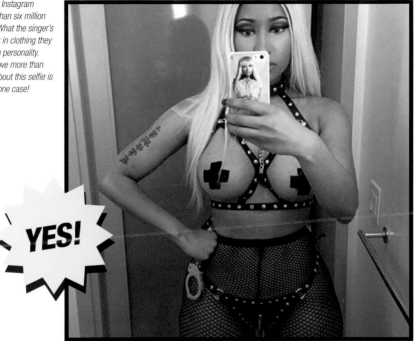

Ms Minaj's Instagram has more than six million followers. What the singer's selfies lack in clothing they make up in personality. What we love more than anything about this selfie is Nicki's iPhone case!

YES!

NICKI MINAJ

If there were one word to describe the wonderfully carefree and fiery singer, it would be saucy. Nicki Minaj is the quintessential modern American singing icon and her selfies often give her fans an insight into her life, tastes – and risqué personality.

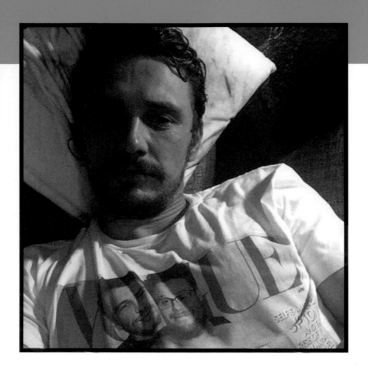

JAMES FRANCO

James Franco is, without a doubt, the world's most loved, and prolific, celfie taker. And, perhaps, also the most controversial. In December 2013, the acclaimed actor wrote a love-letter to selfies for the *New York Times*. The actor insists that, for celebrities at least, the celebrity selfie will hopefully bring an end to a famous person's arch nemesis – the paparazzi. "The celebrity selfie is not only a private portrait of a star, but one also usually composed and taken by said star – a double whammy. It is the prize shot that the paparazzi would kill for", he wrote.

RICK MASTRACCHIO

"The space suit makes it very difficult to get a good selfie. I tried several today." wrote NASA astronaut Rick Mastracchio in April 2014. Mastracchio took a seriously impressive selfie during an EVA (short for Extra-Vehicular Activity), while resident on board the International Space Station. The astronaut may win the title for coolest selfie ever, though NASA is beginning to release so many cool astronaut selfies it's hard to keep up. It makes us wonder what astronaut selfies of the future will look like. No doubt they will be out of this world!

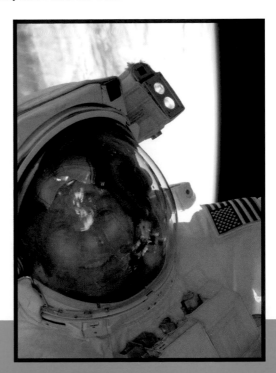

JUSTIN BIEBER

The controversial but much loved US singing sensation Justin Bieber is one of the most prolific selfiers. He was made famous by the Internet when discovered on YouTube aged just 13, but it is Bieber's topless welfies – and in particular the one below – that whet his fans' appetites the most.

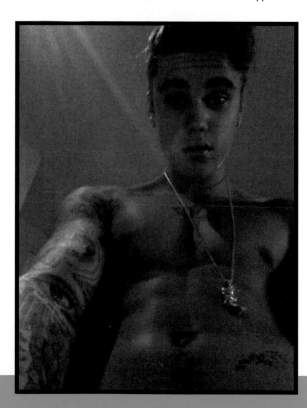

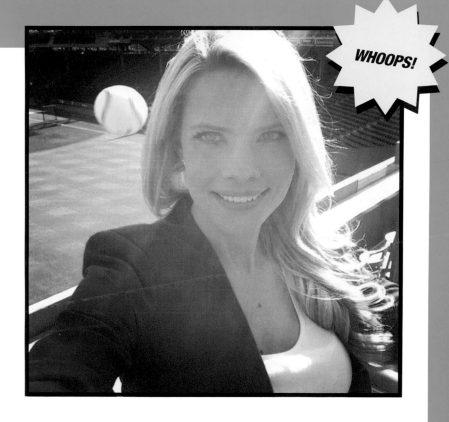

WHOOPS!

KELLY NASH

Tampa Bay Ray sideline reporter Kelly Nash's famous Instagram selfie went viral in 2013 while reporting for Fox Sports Florida. "I took my chances turning my back on batting practice for a selfie!" she said afterwards. Heads up!

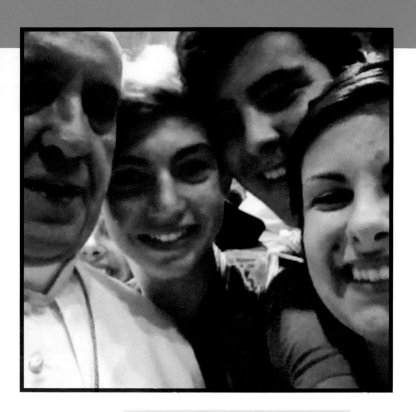

POPE FRANCIS (AND GANG)

The world's first Papal Selfie was taken by a group of Brazilian students on pilgrimage to the Vatican City in August 2013. Pope Francis met with more than 500 teenagers that day, and was a good sport when asked if he would join in with the group shot. The image, posted by Instagram user Fabio M Ragona, went viral – with hundreds of thousands of "Likes" within 24 hours.

FERDINAND PUENTES

Ferdinand Puentes made the international headlines when he took this stunning selfie moments after his plane crashed in the Pacific Ocean in January 2014.

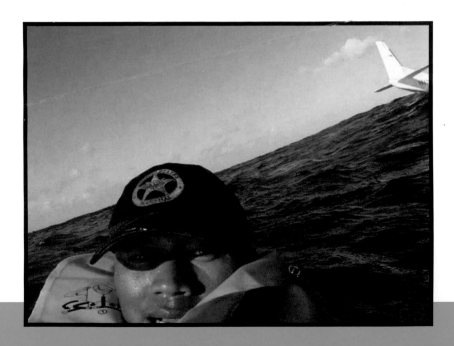

Saucy selfies that get the imaginations fired and the appetities whetted are becomingly increasing popular among celebrities, but also among us regular folks too – you don't need us to tell you why.

LINDSAY LOHAN

Lindsey Lohan's selfies leave little to the imagination, but are usually nothing more than fleeting teases rather than anything salacious or grimy. This is a fairly tame post, compared to some of her even more revealing ones!

LADY GAGA

Ms. Gaga is no stranger to bearing all in her Instagram posts too. In July 2014, this nipple slip while on board a private jet got the tongues of a million #monsters wagging in a frenzied unison. We doubt it was a selfie fail, do you?

KYLIE JENNER

This amazing saucy shot shows off Kylie's body, no question. But this selfie caused a stir online when it appeared the image had been somewhat hastily photoshopped, posted, then deleted, then re-photoshopped (perfectly this time!) and then re-posted.

Unexpected selfies come in various shapes, sizes, colours and packages. They always send social media into a total meltdown, though, just like these three famous selfies did...

JAMIE OLIVER AND RIHANNA

World-famous chef Jamie Oliver and world-famous singer Rihanna caused a stir when they appeared in this selfie posted to Oliver's Instagram account, during the World Cup Finals in July 2014.

EPIC BELFIE!

CHERYL FERNANDEZ-VERSINI

Girls Aloud singer and X Factor judge Cheryl Fernandez-Versini used a glorious belfie to show off her new bottom tattoo to the world. Reactions to the dramatic inking were mixed – but the cheeky belfie itself was praised.

DEMI MOORE

The actress, and one-time wife of Ashton Kutcher, posted this mirror selfie, no doubt to show her ex-husband what he was missing out on. The mirror in the bathroom may not have steamed up, but Twitter certainly did when the steamy bikini selfie was posted.

Epic Selfie Fails

> For every perfect selfie out there in the world, there's a thousand hilarious – and often ridiculous – selfie fails. These are just some of the very best and worst ... we'll leave it to you to decide just how bad they really are!

Whether it's armpit hair, or EXTREME IN-YOUR-FACE CLOSE-UPS, Madonna is not afraid to be controversial with her selfies. This post-gym welfie of an incredibly sweaty Madonna, tagged with the words "addicted to sweat !!!!", is a selfie FAIL!

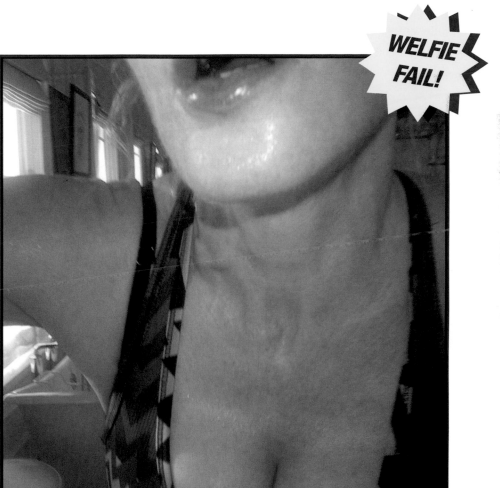

WELFIE
FAIL!

Celebrities are just as prone to epic selfie fails as the rest of us. In fact, when it comes to selfies, the brighter the star – the dimmer they are!

HARRY STYLES

Mr One Fifth of One Direction rarely looks bad, does he? But this telfie (toilet selfie) does him no favours. Although he still looks perfect, so it's hard to say. What do you think? Is this a selfie fail or not?

KELLY ROWLAND

GOOD NEWS: Drinking and driving is now less common than texting and driving. BAD NEWS: taking selfies while driving incidents are on the rise, with one in three young people admitting to taking a selfie while driving.

MILEY CYRUS

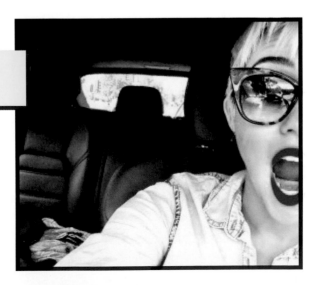

Though we usually love Kelly's and Miley's selfies (probably a little too much, in fact), we must admit that their driving selfies are a bit ridiculous. Dear celebrities, please keep your eyes on the road from now on! Yours sincerely, your fans.

USHER

Usher's selfie of him cooking a solitary egg while cooking in just his briefs proved to be a selfie too far for the 'Burn' singer – who was perhaps in danger of being burnt himself, standing so close, and so naked, to an open flame.

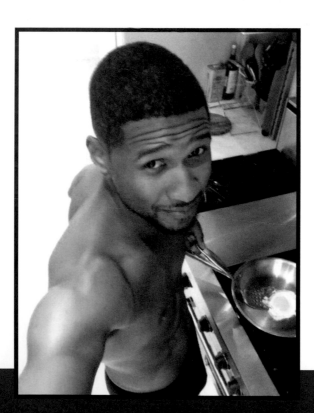

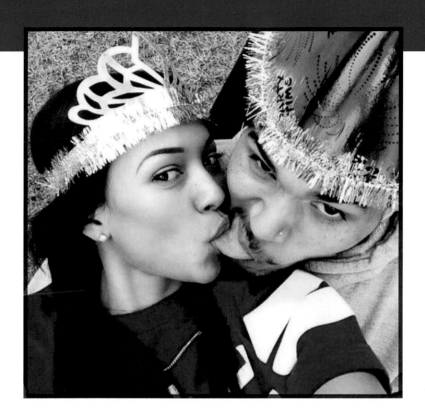

CHRIS BROWN

Selfies are sometimes the worst way to show-off PDAs, as this queasy selfie of rapper Chris Brown and Karrueche Tran demonstrates. It was posted on New Year Eve's 2013, and we can only hope that their New Year's Resolution is to perhaps not to share so many tongue-sucking selfies with the world.

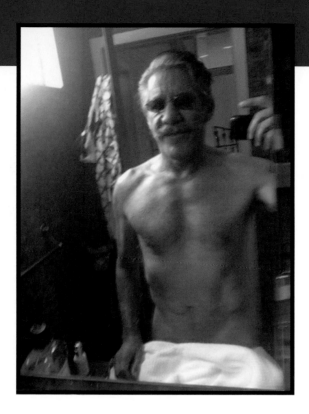

GERALDO RIVIERA

"I was drunk and lonely," was the defence claimed by the King of US Talkshows Geraldo Rivera when he posted this rather saucy selfie in September 2013.

DAVID CAMERON, BARACK OBAMA AND HELLE THORNING-SCHMIDT

While funeral selfies are on the rise, and the Internet is full of bizarre sites and images of selfie-fans pouting near relative's caskets, the most notorious funeral selfie was taken by Barack Obama, David Cameron and Helle Thorning-Schmidt at Nelson Mandela's Memorial service in December 2013. This selfie went mega viral, if not just for the inappropriate actions of three of the leaders of the free world, but for Michelle Obama's very stern disapproval too.

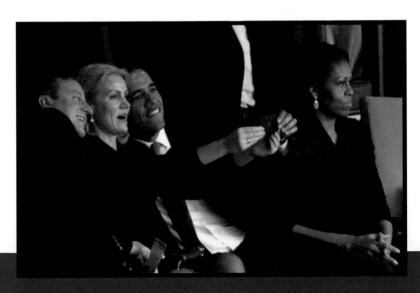

MARIAH CAREY

In October 2013, Mariah Carey shared a very steamy selfie on Instagram for her 1.5 million plus fans, even though the post was labelled for her husband Nick Cannon, who was celebrating his birthday. Was this a text message sent in error as an Instagram message – or simply a cunning tease by Carey to show off her best assets to her fans and what we are missing out on? You decide!

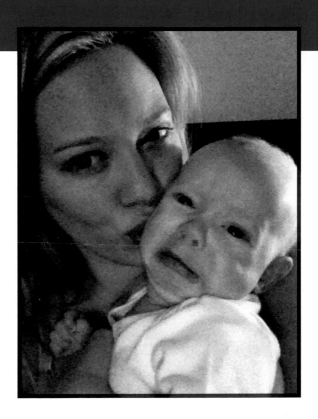

HILARY DUFF

Actress Hilary Duff sparked the attention of the world's press – and sympathy of mothers everywhere – when she posted a selfie with her new-born baby Luca in 2012. The photo was widely ridiculed as "how not to take a baby selfie", but Duff's pride and affection won over. We think it's great!

Celebrity Photobombs!

> " Hot on the heels of the selfie is another popular trend – the celebrity photobomb. No glitzy award show, or fancy celebrity event, is complete without one these days. Let's take a brief break from selfies and have a sneak peek at photobombs! "

Best celebrity photobomb ever? Sherlock actor Benedict Cumberbatch joins in the red carpet fun with Irish rock band U2 at the Oscars 2014 ceremony.

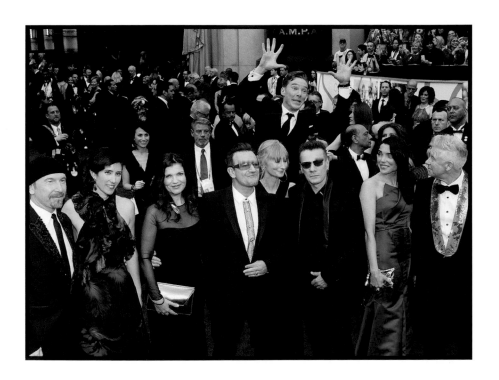

91

When it comes to proflific celebrity photobombing, it's not always just the limelight-hogging celebrities you might expect! Often acclaimed actors who have won handfuls of Academy and BAFTA awards try and get in the way too...

#1 JARED LETO

Oscar-winning "serious actor" and credible musician Jared Leto took great delight in photobombing everybody's selfies at the 2014 Oscar ceremony. One of the most shared images on Instagram after the event was his badass bombing of Ireland Baldwin's selfie with Kevin Spacey.

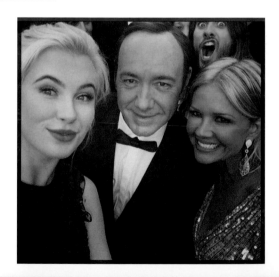

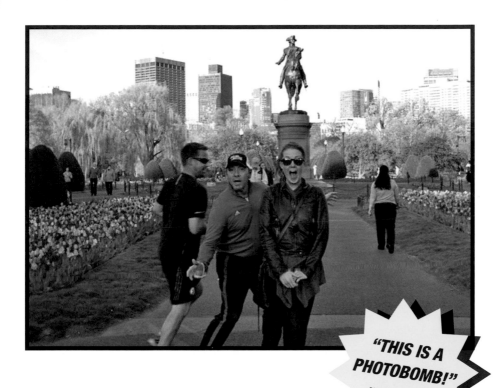

#2 KEVIN SPACEY

Kevin Spacey's love of photobombing "regular" people's photographs reached a whole new level when the *American Beauty* star leapt into this shot while taking a jog around Central Park, New York. Spacey also shouted, "This is a photobomb!" – which makes the whole situation even cooler. The couple's photo – pictured with Kevin is Christina Sandler – instantly hit the celebrity news sites and went viral. Within days it was posted to social media photo site Reddit.

#3 JUSTIN BIEBER

In 2011, at MTV's Video Music Awards, Justin Bieber pulled off, the world's creepiest photobomb when he came between Katy Perry and Russell Brand. Brand's face says it all!

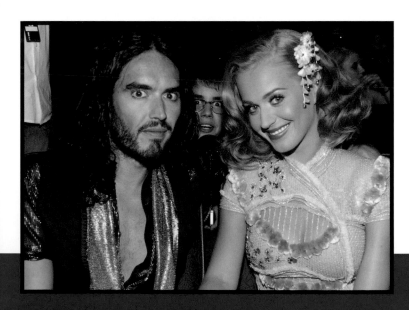

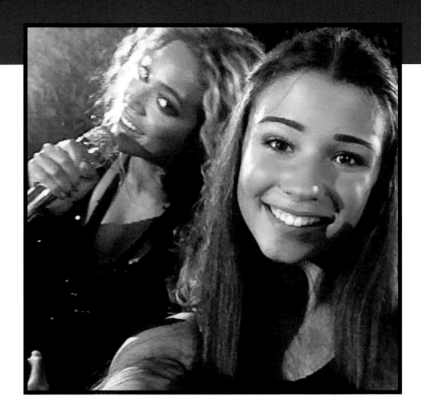

#4 BEYONCE

Queen Beyoncé jumped in at the exact moment as mega-fan Valentina took this amazing selfie. Hoping to capture a glimpse of the star as she positioned her camera, Beyoncé seized the selfie and photobombed! The moment, posted to Tumblr and also caught on video, went super viral ... and proves that when it comes to selfie's nobody does it better than Beyoncé.

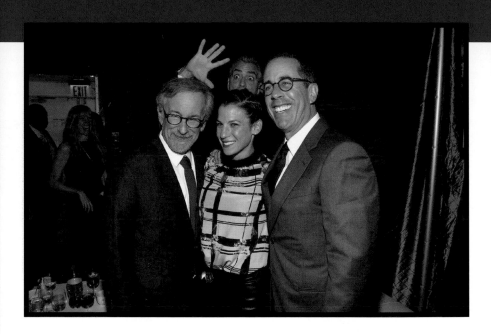

#5 GEORGE CLOONEY

Normally perceived as the suave and elegant actor, the very cool George Clooney took great delight in photobombing Steven Spielberg, Jessica Seinfeld and Jerry Seinfeld!

#6 TOM HANKS

Probably the most infamous celebrity photobomb of all time, having been viewed and shared over a million times since it was posted in August 2012. Tom Hanks' face is legendary as he affectionately ridicules a supposedly "wasted" diner while on a night out in a restaurant in Fargo, North Dakota.

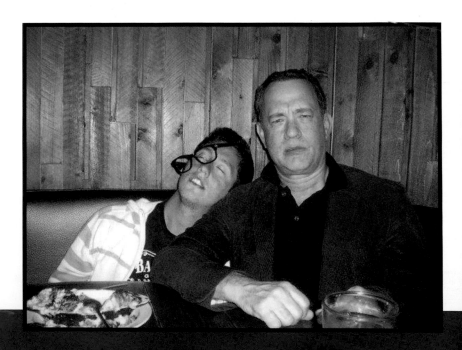

#7 DWAYNE JOHNSON

With the rise of the celebrity selfie hopefully killing off the photograph-for-profit paparazzi trade once and for all, celebrities like Dwayne "The Rock" Johnson have a lot to smile about when their fans snap them in the street. This photo was shared online via Facebook.

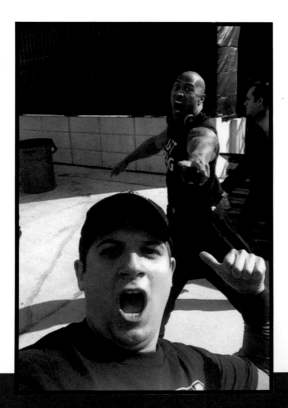

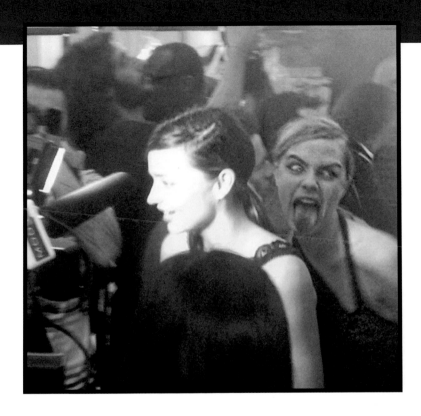

#7 CARA DELEVINGNE

Supermodel Miranda Kerr posted this amazing shot of another supermodel, Cara Delevingne, photobombing a live TV interview. Cara's face is legendary ... and very scary!

Selfie Fever!

It was the year 2000 when the first camera phone was released onto the world. Since then there has been an explosion of selfie-related gadgets, tech, apps, filters and hashtags that have helped increase the amount of fun we can have! Here's a quick a look at the stuff that made us laugh...

Stadium rockers and international chart toppers 5 Seconds of Summer share a selfie within a selfie within a selfie.

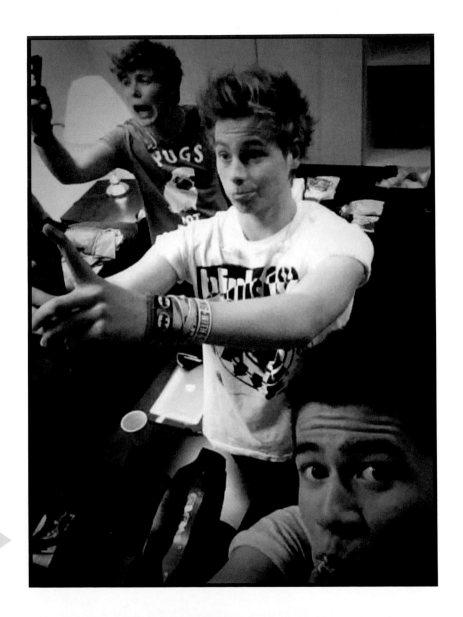

Top Five Instagram Filters

Colour editing filters on Instagram are a powerful way of injecting/erasing brightness into a selfie to help get across your facial expressions. They are also a great way of removing the nooks and crannies you want nobody else to see. One of the main reasons Instagram took the world by storm when it first launched is its super selection of selfie filters...

Demi Moore goes a little too crazy with filters!

Here's our rundown of the five best Instagram filters for selfies:

 Willow – softens features and contours, and looks the best when make-up is applied bold and dark

 Mayfair – makes your photo look richer in tone, and brings out subtle highlights and contours – ideal if you're not wearing any make-up. Apart from using no filter, Mayfair is Instagram's most popular filter

 Amaro – this reliable filter helps wash out any skin imperfections and gets your make-up to really stand out

 Toaster – does exactly what it says on the tin. Makes your skin look golden and toasted. It's the least used Instagram filter, but that's probably because most people are too lazy to scroll through to the end!

 Walden – the perfect filter for showing off your skin

Selfie App-iness!

There are a plethora of various selfie apps, each one declaring that they help you to take the perfect selfie. Here's three of the best to help your selfies stand out from the rest...

#1 FACETUNE

If you want to photoshop your hungover and bleary-eyed features on the go, then Facetune is the app for you. The app can remove wrinkles, acne, scars, and bags under your eyes, erase red eye and even whiten your teeth! A great app if you're trying to impress a new follower! And it's free! But don't get too carried away...

Abbie Cornish, the Australian beauty from the movie Limitless, posts a provocative selfie using Willow – Instagram's black and white filter.

#2 FRONTBACK

Beloved by Mila Kunis and Ashton Kutcher, the Frontback app is one of the most widely used selfie apps. The app splits the screen so you can take a front and back photo at the same time; the front camera shoots a picture of you, and the back camera shoots what you see. The app then merges them together. Clever stuff.

#3 SELFIE CAM APP

Included with this app is a smile activated timer – using iOS 7 face detection technology – meaning you're not required to look at the camera, the app will know when the best time to take the photo is. Once you've got the perfect shot, this free app allows you to decorate yourself with funny hairdos, facial hair and accessories, all while using the rotary controller.

Frontbacks can show who you are, where you are and what you're doing – all at the same time!

The Rules of Selfie Photoshopping

Many naturally beautiful celebrities have been accused of altering their selfies in order to accentuate their favourite parts (and hide others). The Internet is full of conspiracies on these matters, but forget about them – here's a brief guide to how not to photoshop your selfies...

Editing your selfies is consider a big no-no – why change how you look, you're perfect just as you are. Psychologists have declared war on selfie photoshop apps because they skew societies view on beauty (and can lead to anxiety and depression), can cause addiction and, perhaps most important, let other people know that we are OK with people viewing a false image of who we are. However, we admit the temptation to tweak, re-touch and tinkle is huge ... but try and resist!

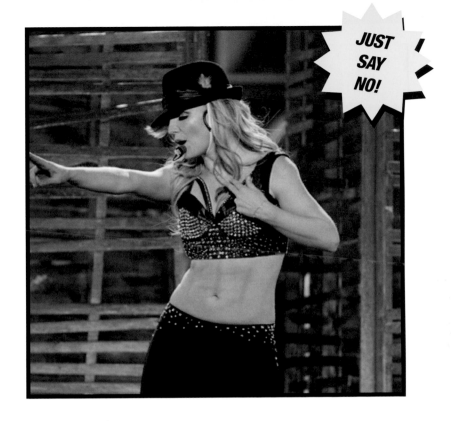

JUST SAY NO!

#1 NEVER GIVE YOURSELF A SIX PACK!

You may not have been to the gym this week, or the past few months, but fight
the urge to re-touch an image that shows off your bare midriff, or a beach snap.
In 2013, Britney Spears was accused by some of her fans for retouching this
Instagram post, giving herself a six-pack of abs. What do you think? Fake or not?

#2 DON'T ALTER YOUR WAISTLINES

When Kim Kardashian posted this image online in 2013, Photoshop wizards pounced on it. While there is no denying Mrs Kanye West has a gorgeous body, her temptation to alter it ever so slightly can be seen in this Instagram post. Notice the slight curve in the door frame behind her – evidence of perhaps a tiny tinkering around her waistline?

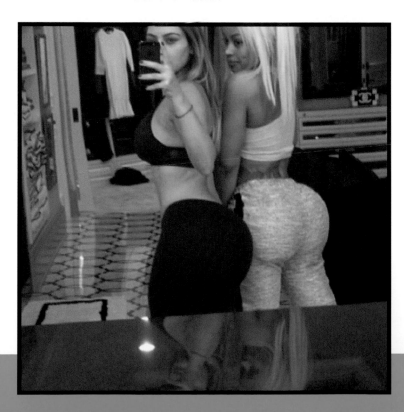

#3 BE PROUD OF WHO YOU ARE

A bit cheesy for anyone to say, we think it's hugely important for us to get across just how proud you should be of who you are and not change a thing. Besides, if the beautiful Nicole Scherzinger, Pussycat Doll extraordinaire, can post imperfect selfies – like the one above – then so can you!

The Selfie Stick

The Selfie Phenomenon has been responsible not only for a gazillion selfie apps and new-fangled smartphone technology, but also for the now infamous selfie stick. Never again will you take a selfie where someone's face is half chopped off...

The perfect and most popular selfie accessory of 2014 has been the selfie stick. It needs no further introduction – it's a stick you attach your phone to! It helps you and your friends capture the perfect group shot – or "ussie" if you prefer. Make sure the phone is extended out long enough for you all to squeeze in. The invention of the elfie stick has also helped daredevils capture some amazingly insane selfies too!

OTHER SELFIE ACCESSORIES YOU CAN BUY (IF YOU WANT!):

Selfie Brush (an iPhone case with a mounted hairbrush on it)

...

A 'Keep Calm and Take A Selfie' T-Shirt and fridge magnet

...

'The Selfie Song' by the Chainsmokers. The first ever song released about selfies.

Actor and comedian John Stamos uses the ultimate Selfie Machine on his holiday to Honolulu – the Quickpod. Selfie Sticks and Quikpods are available from Amazon and eBay – or you could just make your own one with a stick and some tape!

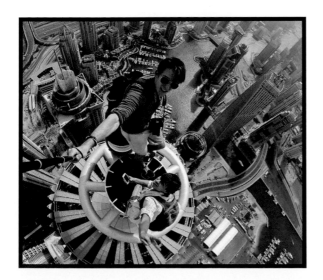

Thrillseeker Alexander Remnev takes the world's highest selfie using a selfie stick, atop Dubai's Princess Tower – 1,350ft (412m) off the ground.

The Selfie Head Tilt

Have a look through your selfies. Do you notice a common theme among them? That's right, you're no doubt tilting your head to a ridiculous degree. Don't worry, it's perfectly normal. In fact, when it comes to selfies it's mandatory!

Head tilting. Women do it more than men. And women in New York turn their head much less than women in Brazil, who prefer a much more dramatic head tilt. This is all according to "selfie research" undertaken by Selfiecity, a 2014 study on the science of selfies. Researchers for the experiment, analyzed 650,000 Instagram selfies and reported their findings. The most pertinent fact revealed in the study is that women from Sao Paulo, on average, tilt their heads to a startling 16.9°.

So, what's your tilt of preference?

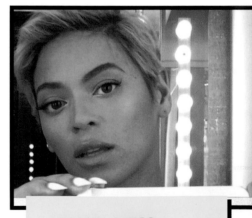

#1 LIKE THIS?

Beyoncé performs a slight 0.3° head tilt, as most US females do.

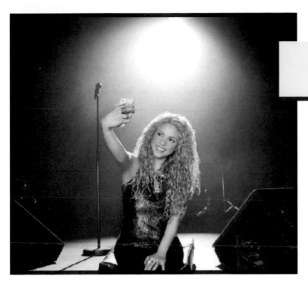

#2 OR LIKE THIS?

Shakira displays a more pro-
nounced head tilt when she takes
her selfie.

#3 NEVER LIKE THIS!

Lady Gaga is famous for her
severe head tilt. Check out her
Instagram account and count
how many selfies she tilts her
head in – it's ridiculous!

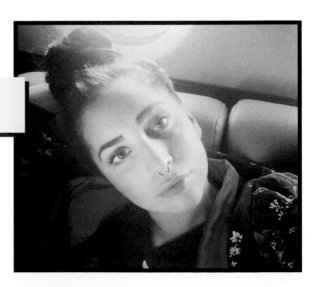

Say #Hello to Hashtagging

Taking selfies isn't just about getting the camera angle perfectly balanced to show off your best side. Making sure people see your selfies is also all about knowing how to #hashtag properly too.

Whether it's news events, scandals, selfie types or identifying that you belong to a group (#beliebers or #directioners, for example), hashtags are an important part of the selfie phenomenon. Marketing managers the world over now use hashtags to brand, promote and label products, campaigns and events.

#SOMETHINGTOREMEMBER ABOUT HASHTAGS

If you want your selfie to be seen by more than the same five people, then the most popular hashtags to deploy are: #boy #girl #pretty #daily #hair. This will increase your visibility to others by other 75 percent (as long as you're set to Public). You are allowed no more than 30 hashtags per picture – so choose wisely.

THE MOST POPULAR SELFIE #HASHTAGS ON INSTAGRAM TO INCLUDE:

#selfie

#instagood

#me

#picoftheday

#nofilter

#followme

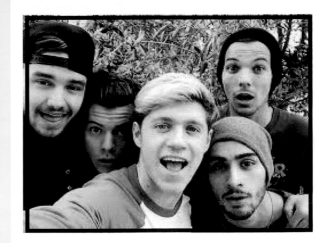

One Direction's Directioners have posted more than 4 million #directioners posts on Instagram.

#hashtag fact
A hashtag is actually called an octothorpe.

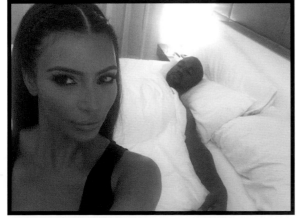

Kim Kardashian's brilliant bed selfie of her husband, Mr Kanye West, received more than 1.3 million FB "Likes".

115

Selfie Etiquette

Mastering the art of selfie taking isn't just about how noticing how good your selfies are getting, it's about "Liking" and commenting on how amazing your friends' selfies are too. Frequently "Liking" other people's selfies helps their selfie-confidence rise but also means they are more likely to "Like" yours in return too!

Selfie etiquette is an important part of the selfie phenomenon. In order for the selfie universe to survive we all have to "Like" as many selfies as we can. Without people commenting on how awesome your selfies are – and vice versa – the whole selfie universe could implode. Not only is it nice to pay someone a digital compliment at least a few times every day, it's also nice to receive one, isn't it? So, get your fingers ready to press "Like" at least 20 times today – you'll feel better and, after all, isn't that what selfies are all about?

Idris Elba posts a "wifi selfie" to his 200,000+ Instagram followers. They showed their appreciation with thousands of "Likes".

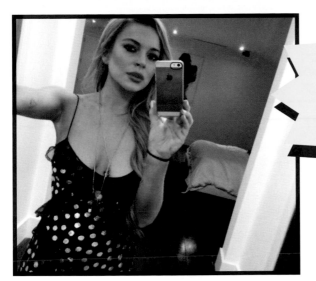

An average non-celebrity selfie usually earns a maximum of eight "Likes".

Lindsay Lohan's full body selfie, or fullie, isn't as interesting as some of her other selfies – but still received more than 200,000 "Likes".

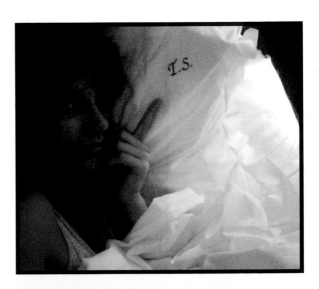

Taylor Swift's selfies are sometimes regarded as "boring", but she still receives more than 750,000 "Likes" per image!

Selfie-by-Numbers

> The Selfie phenomenon has not only made the word 'selfie' as famous as the act of taking one, it has also thrown up many interesting statistics and numbers too, each one giving that little bit more insight into why this trend will outlast us all.

NASA's astronaut selfies often get a ridiculous number of shares and reposts, which thankfully encourages NASA to think up even more adventurous and daring selfies. Pictured here snapping a seflie of himself is astronaut Mike Hopkins.

SPACE SELFIE!

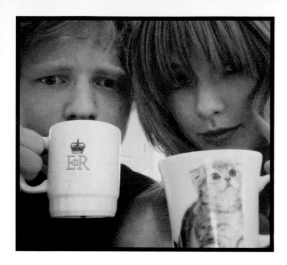

BFFs Ed Sheeran and Taylor Swift share a cup of tea in their selfie that launched a thousand tongues wagging about their friendship.

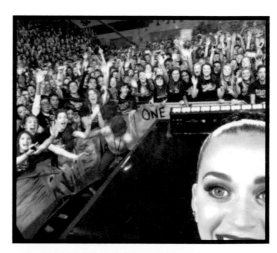

Katy Perry posts an awesome onstage selfie to her 55+million Twitter followers.

1 Despite Instagram being the home of the celebrity selfie, 48 percent of all selfies taken by non-famous people are posted to Facebook

2 Between the ages of 18 and 24, selfies take up 30 percent of every photo taken and posted online

3 Images with cooler blues and greens receive more "Likes" than images with reds, oranges and pinks, a recent study revealed

4 The original "#selfie" label on Instagram grew more the 200 percent in usage since January 2013 to July 2014. In January 2013, #selfie wasn't even one of the top 100 hashtags used on Instagram

Comedienne Rebel Wilson's Instagram account is littered with hundreds of hilarious selfies such as this...

1 The celebrity with the most amount of selfies so far is Kylie Jenner – of Keeping Up With the Kardashians – with more than 450 selfies! And that's only since July 2012. Kylie is Queen Selfie – all hail!

2 According to a recent poll, the top five places selfies are taken are: 1. Holiday 2. Living room 3. On a night out 4. The bedroom 5. At an event, such as a festival or show. Have a look through your selfies – where do you take the most?

3 According to a recent study, the top five reasons people take selfies are:

1. To remember a happy moment

2. To capture a funny moment

3. To capture a nice outfit

4. Because they are feeling confident

5. To capture a good hair day!

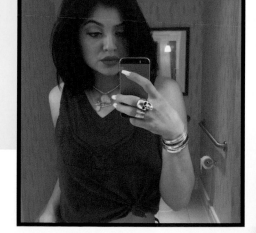

With her own brand of #Selfie t-shirts in the shops soon, the world's most prolific celebrity selfie taker – more than even her own half-sister Kim Kardashian – is, of course, Kylie Jenner. Kylie has more than 11 million Instagram fans.

The king and queen of social media Ashton Kutcher and Mila
Kunis have perfected the art of posting romantic selfies that don't
want to make you throw up!

Acclaimed filmmaker and actor Zach Braff loves close-up selfies, which has earnt him a healthy following of fans, despite being a relative newbie to the selfie scene. This particular shot was captioned with, "I can see what you're doing!"

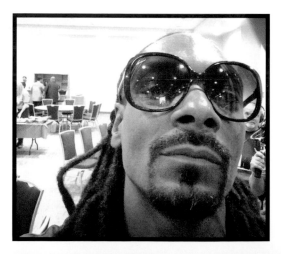

Snoop Dogg is one of Instagram's most famous and prolific selfie snappers. With more than 4 million fans, Snopp's selfies have become notorious, not only for their content but for Mr Dogg's legendary love of fancy dress.

1 'The Selfie Song' by the Chainsmokers has hundreds of millions of views. Check it out – it's ridiculous!

2 69 percent of selfie takers have never altered their selfies in any way

3 National Selfie Day is April 7. What will you do to celebrate?

4 Two out of five people admit that they take up to ten selfies before they post just one that they are happy with

5 Only six percent of us have ever dared take a belfie. Are you one of them?

6 28 percent of selfiers admit to taking a selfie at the airport – just to let people know they are going on holiday!

Selfies in the News

> " With the Selfie phenomenon becoming a major social trend, it has also become a popular news story in itself. This, of course, leads to a variety of some very tragic, uplifting and emotional selfie stories indeed. "

Oprah Winfrey's first ever selfie gets photobombed by Idris Elba.

Actress and comedienne Lena Durham has established a reputation on Instagram for oversharing when it comes to her hilarious selfies. Many of her fans' comments revolve around the letters TMI!

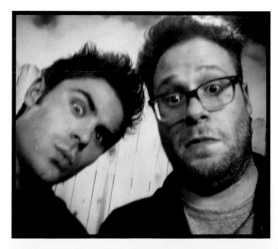

Hunky hearthrob Zac Efron and funnyman Seth Rogen shared this selfie while bored doing publicity for their 2014 movie Neighbours. "Me and Zac are attempting to do press. The Germans love our jokes." Rogen commented; 55,000 fans "Liked".

1 The online world went bananas in July 2014 when it was announced that the world's first "selfie toaster' was available to buy. What does it do? It burns an impression of your face onto your toast – uploaded from any selfie you choose from your phone!

2 A prominent "selfie addict" tried to commit suicide in July 2014 when he couldn't take the perfect photo of himself. The Instagram-obssessed teenager, who took more than 200 selfies a day, dropped out of school, did not leave his house for over six months and lost more than two stone trying to make himself look better for his selfie

3 In 2015, the world's first selfie-related social networking site www.selfie.com goes live. Watch this space!

4 In July 2014, astronaut Buzz Aldrin posted a tweet that said: "Did you know I took the first space selfie during Gemini 12 mission in 1966. BEST SELFIE EVER" along with said selfie. Admittedly, it's a pretty dazzling selfie

The world's first selfie taken by a farmyard animal was taken in April 2014, when a three-week-old lamb in Devon accidentally stood on its owner's phone. Farmer David Fursdon posted the image on Twitter – and few could disagree with the owner's claim. It is indeed a sheep selfie – a sheepie!

In August 2014, a 21-year-old from Mexico City, accidentally shot himself in the head while posing for a selfie with a loaded gun. Oscar Otero Aguilar was amongst friends when the accident happened. He died on the way to the hospital

Analysis by Time *magazine has revealed the top ten most selfie-obsessed cities in the world. The magazine researched over 400,000 selfies uploaded to Instagram in March 2014 and published their unique findings. The Top Ten cities that take selfies the most are:*

1. Makati City and Pasig, Philippines (258 selfie-takers per 100,000 people)

2. Manhattan, NYC (202 selfies/100k)

3. Miami, Fla (155 selfies/100k)

4. Anaheim and Santa Ana, Calif (147 selfies/100k)

5. Petaling Jaya, KL, Malaysia (141 selfies/100k)

6. Tel Aviv, Israel (139 selfies/100k)

7. Manchester, England (114 selfies/100k)

8. Milan, Italy (108 selfies/100k)

9. Cebu City, Philippines (99 selfies/100k)

10. George Town, Malaysia (91 selfies/100k)

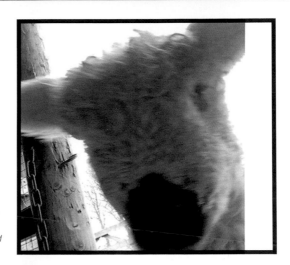

Online news sites when bonkers in April 2014 with news that the first ever "sheepie", or sheep selfie, had been taken.

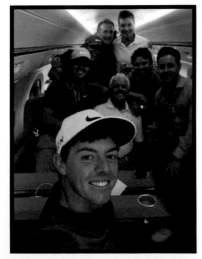

World Number One golfer Rory McIlroy is a selfie fanatic, constantly sharing amazing (and obligatory) selfies almost immediately after his victories. He is pictured here tweeting a selfie on the plane to New York after winning the US PGA Championship.

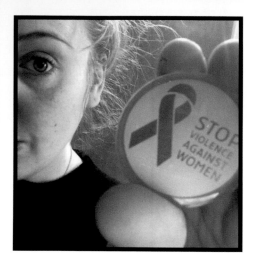

In an extremely rare selfie, the most succesful singer of the modern age, Adele, posts a meaningful selfie to her official Twitter account to speak out against the Violence Against Women campaign.

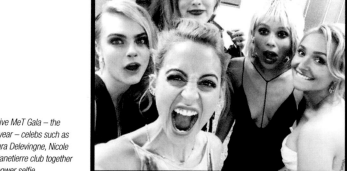

At New York's exclusive MeT Gala – the fashion event of the year – celebs such as Zooey Deschanel, Cara Delevingne, Nicole Richie and Hayden Panetierre club together to produce this girl-power selfie.

8 Despite loathing the paparazzi, actor Jude Law refused to have a selfie taken with a fan in April 2014. "I don't do selfies," he exclaimed

9 With news that black cats are being evicted from houses all over the world because they "don't look good in selfies", it's comforting to know that cat pictures are still more popular than selfies. In fact, more than 4m cat pictures and videos are shared on social media networking sites in the UK every day – almost three times the amount of selfies

10 A teenager has landed in even more hot water than he was already in when he took and uploaded a selfie – while seated in the court dock waiting for his trial to begin. The selfie was uploaded with the caption "Lads in the court box lol". The teenager, from Bournemouth, UK, was fined and charged with publishing a photograph of a criminal court under the Criminal Justic Act

11 In the US, selfies have been blamed as one of the root causes in the increase in head lice amongst teenagers. It may sound dramatic, but the repercussions of getting a few heads together to squeeze into a group selfie has begin to show links to a decrease in head health in American teenagers. "Selfies are fun, but the consequences are real," Marcy McQuillan, of Nitless Noggins, Scott Valley, California, claimed

12 A controversial Selfie-based app called SkinneePix, launched in April 2014, allows its users to edit their selfies to look 5lb, 10lb or 15lb slimmer. "No one needs to know. It's our little secret," the description on Apple's App Store reads. I do hope none of you have bought it…

13 Renowned photographer David Bailey reacted negatively to the selfie craze. "People won't be doing it in six months' time," he said. "There will be another craze, I can't see the point." Do you agree?

14 Ever wondered why selfie is spelled "selfie"… and not "selfy"? Judy Pearsall, Editorial Director for Oxford Dictionaries, has the answer. "In the early days of selfie, both –y and –ie suffixes were common," she said. "The use of the diminutive -ie suffix helps to turn an essentially narcissistic enterprise into something rather more endearing." Fair enough!

In among the hundreds of pelfies with her pet dog, actress Amanda Seyfried shows her Instagram fans the hard work she puts into getting ready for a glitzy awards show.

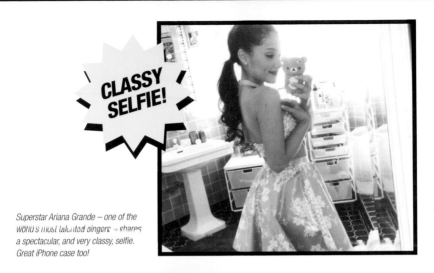

CLASSY SELFIE!

Superstar Ariana Grande – one of the world's most talented singers – shares a spectacular, and very classy, selfie. Great iPhone case too!

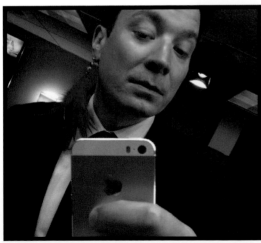

America's favourite talkshow host Jimmy Fallon posts a hilarious selfie after legendary actor Harrison Ford pierced his ear live on air. Many of Fallon's nightly shows contain at least one selfie moment with his famous guests.

Selfie Trends

> "Despite the critics and the naysayers, selfies seem to have the stamina to stick around for the long haul. That's largely in thanks to the imaginative ways that people are coming up with to continue making selfies fresh and exciting. Ladies and gentleman, we give you the world's best selfie trends…"

Susan Sarandon posts a Throwback Thursday of herself and co-star Geena Davis taking a selfie in Thelma & Louise *and a more recent shot. Ms Sarandon credits the film's famous scene as the "inventors of the selfie".*

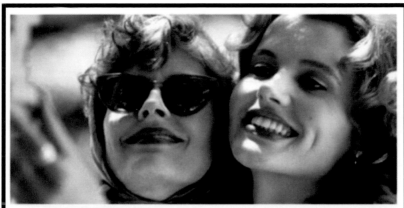

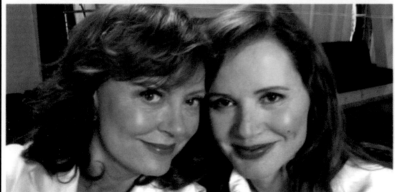

 Susan Sarandon
@SusanSarandon

 Follow

Inventors of the #selfie at it again. #ThelmaAndLouise

10:24 PM - 19 Jun 14 Reply Retweet ★ Favorite

Throwback Thursdays (or #TBT)

Throwback Thursday is, without a doubt, the most popular selfie trend. Everyone is doing it now. Instagram has more than 45 million posts for ThrowbackThursday, but more than 250 million posts for #TBT. Get your old photos out and get posting, people!

If you don't already know, ThrowbackThursday is, basically, posting an old selfie of yourself from years ago and tagging it #TBT to reminisce about fun times from your childhood or a moment in history. It's a digital trip down memory lane, which you can share with the whole world. The older the photo, the better. And – this should go without saying – the more embarrassing the photo, the better!

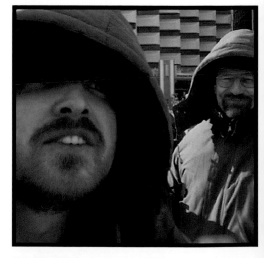

Fans of the hit TV show Breaking Bad *will break into a sweat seeing this #TBT from actor Aaron Paul while on set with co-star Bryan Cranston.*

Rihanna ✓
@rihanna

When I was 17, I took my first selfie! #RihannaBETAwards

[Follow]

Rihanna posts a ThrowbackThursday selfie from when the singer was just 17 and appearing at the BET Awards. The singer claims this selfie to be her very first!

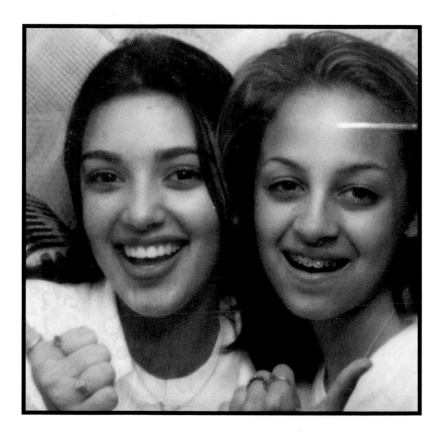

My, how she's changed: The world's most celebrated selfie star, Kim Kardashian, posted her very own ThrowbackThursday photo in January 2014, alongside Nicole Ritchie. It is a beauty!

The woman who inspired Sex and the City, *Candace Bushnell posts an amazing #TBT selfie with the caption "#ThrowbackThursday Ah, the good old days. Drinking Cosmos and smoking." Carrie Bradshaw would be proud!*

Statesman Colin Powell, a retired four-star general and public figure, is not above all the trivial selfie nonsense. His #TBT photo got the world buzzing in 2013 with his mirror selfie taken in 1950. General Powell posted on Facebook the caption: "Throwback Thursday – I was doing selfies 60 years before you Facebook folks." Amazing!

Selfie Sunday

If you fancy a little confidence boost on the final day of the week – or just want to post a shameless selfie after an epic Saturday night session – Instagram's popular #Selfie Sunday trend is just the thing you need as the perfect excuse.

Ten million Instagram users swear by #Selfie Sunday (or Selfie Saturday, if you just can't wait). While it's not unlike any other day of the week where you can post selfies, #Selfie Sundays are usually very relaxed, at home, in-your-pyjamas and watching TV so are sometimes seen as a nice contrast to the glitzy, hectic and hard-working selfies you shared earlier in the week to show how cool, busy and hectic you were. So, put your PJs on, leave the make-up off and show the world that today is *your* day of rest...

Actress Anna Kendrick brings elegant attitude to her sweat pants and hoodie #selfiesunday style!

Hart of Dixie *actress Jaime King shares a relaxed selfie. The added lens blur effect helps us focus on Ms King's face and hair and not her kitchen cupboards.*

Credits

P5 / Jenn Lee / Instagram
P7 / Nicole Richie / Instagram
P9 / Jennifer Love Hewitt / Twitter
P11 / Gwyneth Paltrow / Instagram
P11 / Demi Lovato / Instagram
P12 / Jennifer Lopez / Instagram
P13 / Paris Hilton / Instagram
P13 / David Beckham / Twitter
P14 / Tyra Banks / Instagram
P15 / Rihanna / Instagram
P16 / Scarlett Johansson / Twitter
P17 / Rainn Wilson / Twitter
P17 / Ian Somerhalder / Instagram
P17 / Rainn Wilson / Twitter
P19 / Dwayne Johnson / Instagram
P21 / Rita Ora / Instagram
P22 / Kim Kardashian / Instagram
P23 / Katie Price / Twitter
P24 / Sofia Vergara / Instagram
P25 / Aubrey O'Day / Instagram
P26 / Candice Swanepoel / Instagram
P27 / Kelly Brook / Instagram
P28 / Melanie B / Instagram
P29 / Bar Rafaeli / Instagram
P30 / LeBron James / Twitter
P31 / Chris Pratt / Instagram
P32 / Michelle Obama / Twitter
P33 / Katy Perry / Twitter
P34 / Krissy Tiegen / Instagram
P36 / Lady Gaga / Instagram
P36 / Jennifer Lawrence
P37 / Kirill Oreshkin / Twitter
P38 / Lee Thompson / Twitter
P39'/ Cara Develingne / Instagram
P40 / Selena Gomez / Instagram
P41 / Barack Obama / Twitter

P42 / Cheryl Fernandez-Versini / Instagram
P44 / Victoria Beckham / Twitter
P44 / Kim Kardashian / Instagram
P45 / Rosie Huntington Whitely / Instagram
P45 / Nicki Minaj / Instagram
P47 / Heidi Klum / Instagram
P47 / Ireland Baldwin / Instagram
P48 / Kim Kardashian / Instagram
P49 / Danielle Lloyd / Instagram
P50 / James Franco / Instagram
P51 / Amanda Bynes / Instagram
P53 / Karwai Tang/Wirelmage/Getty Images
P54 / Lily Allen / Instagram
P55 / Jennifer Lopez / Instagram
P56 / Victoria Sky Ellis
P57 / Jayde Taylor / Instagram
P57 / Mike White / Instagram
P59 / Heidi Klum / Instagram
P59 / Miranda Kerr / Instagram
P60 / Selena Gomez / Instagram
P61 / Jessica Simpson / Twitter
P63 / Ellen DeGeneres / Twitter
P64 / David Cameron / Twitter
P65 / Patrick Stewart / Twitter
P65 / Rob Delaney / Twitter
P66 / Rickey Gervais / Twitter
P67 / Star Wars / Instagram
P67 / Sellotape Selfie / Facebook
P68 / Miley Cyrus / Instagram
P69 / Nicki Minaj / Instagram
P70 / James Franco / Instagram
P71 / NASA / Twitter
P72 / Justin Bieber / Twitter
P73 / Kelly Nash / Twitter
P74 / Fabio M.Ragona / Twitter
P75 / Ferdinand Puentes / Facebook

P76 / Lindsay Lohan / Instagram
P77 / Lady Gaga / Instagram
P77 / Kylie Jenner / Instagram
P78 / Jamie Oliver / Instagram
P79 / Cheryl Fernandez Versini / Instagram
P79 / Demi Moore / Twitter
P81 / Madonna / Instagram
P82 / Harry Styles / Instagram
P83 / Kelly Rowland / Instagram
P83 / Miley Cyrus / Instagram
P84 / Usher / Instagram
P85 / Chris Brown / Instagram
P86 / AFP/Getty Images
P87 / Geraldo Riviera / Instagram
P88 / Mariah Carey / Instagram
P89 / Hilary Duff / Instagram
P91 / Kevork Djansezian/Getty Images
P92 / Ireland Baldwin / Instagram
P93 / Christina Sandler / Tumblr
P94 / Justin Bieber / Twitter
P95 / Valentina Attard / Instagram
P96 / Larry Busacca/Getty Images for the
USC Shoah Foundation Institute
P97 / Tom Hanks / Reddit
P98 / Boshasaurus / Reddit
P99 / Miranda Kerr / Instagram
P101 / Calum Hood / Twitter
P102 / Demi Moore / Instagram
P104 / Idris Elba / Instagram
P105 / Jessie J / Instagram
P107 / Britney Spears / Instagram
P108 / Kim Kardashian / Instagram
P109 / Nicole Scherzinger / Instagram
P111 / John Stamos / Instagram
P111 / Alexander Remnev / Twitter
P112 / Beyoncé / Instagram

P113 / Shakira / Instagram
P113 / Lady Gaga / Instagram
P115 / One Direction / Instagram
P115 / Kate Upton / Instagram
P117 / Lindsay Lohan / Instagram
P117 / Taylor Swift / Instagram
P119 / NASA / Twitter
P120 / Taylor Swift / Instagram
P120 / Katy Perry / Twitter
P121 / Rebel Wilson / Instagram
P122 / Kendall Jenner / Instagram
P123 / Ashton Kutcher / Instagram
P124 / Zach Braff / Instagram
P124 / Snopp Dogg / Instagram
P127 / Oprah Winfrey / Instagram
P128 / Lena Durham / Instagram
P128 / Seth Rogen / Instagram
P131 / David Fursden / Twitter
P131 / Rory McIlroy / Instagram
P132 / Adele / Twitter
P132 / Nicole Richie / Instagram
P135 / Ariana Grande / Instagram
P135 / Jimmy Fallon / Twitter
P137 / Susan Sarandon / Instagram
P138 / Aaron Paul / Instagram
P139 / Rihanna / Instagram
P140 / Kim Kardashian / Instagram
P141 / Candace Bushell / Twitter
P141 / Colin Powell / Instagram
P142 / Anna Kendrick / Instagram
P143 / Jaime King / Instagram